IMAGES
of America

LECLAIRE

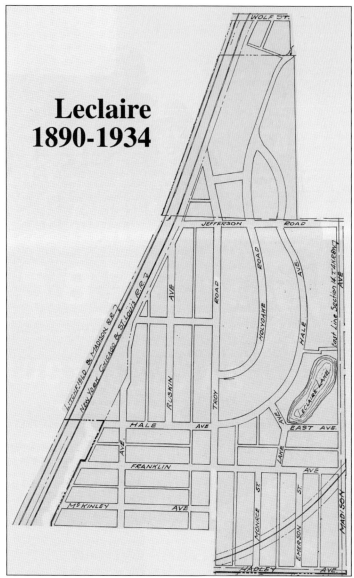

Leclaire 1890-1934

Once located south of Edwardsville, Illinois, Leclaire is now surrounded by that city. At the northern end of this map, drawn when the community was annexed to Edwardsville in 1934, is the area where the factories were located. About halfway between Wolf Street and Jefferson Road was a dividing line separating the factory complex from the Leclaire campus, which had baseball, football, and tennis facilities as well as a bowling and billiards hall. The School House was built between Hale Avenue and Holyoake Road just before they merge at the northern end of Holyoake Road. Hale, Lake, East, and Madison Avenues bound Leclaire Lake and Park. All other property in Leclaire was residential. The unlabeled street bordering the tracks is Longfellow Avenue. (Courtesy of Madison County Historical Society and Creative Options Design.)

ON THE COVER: Salesmen for N. O. Nelson Manufacturing Company pose for a group portrait during a visit to the shops at Leclaire on March 14, 1908. During a demonstration of the marble hoist, a large slab fell, destroying hundreds of dollars in marble stock, but fortunately none of the visitors were injured. (Courtesy of Madison County Historical Society.)

IMAGES
of America

LECLAIRE

Cindy Reinhardt

ARCADIA
PUBLISHING

Published by Arcadia Publishing
Charleston, South Carolina

Printed in the United States of America

Library of Congress Control Number: 2010927122

For all general information, please contact Arcadia Publishing:
Telephone 843-853-2070
Fax 843-853-0044
E-mail sales@arcadiapublishing.com
For customer service and orders:
Toll-Free 1-888-313-2665

Visit us on the Internet at www.arcadiapublishing.com

*This book is dedicated to the many historians
who have helped preserve the story of Leclaire.*

CONTENTS

ACKNOWLEDGMENTS

Through the efforts of Edwardsville's Historic Preservation Commission, Leclaire was added to the National Register of Historic Places in 1979. In 1990, the former village celebrated its centennial. At that time, a group of residents and local historians worked to gather the stories and photographs of longtime residents and to preserve the history of this special place. They formed an organization, Friends of Leclaire, which started a dialogue that continues today, bringing awareness and preservation efforts to the forefront in the Leclaire neighborhood.

To all of these historians, too numerous to name individually, I owe a debt of gratitude.

Many of the images scanned for this book came with wonderful oral histories available only from the descendants of early Leclaire residents. I am grateful to everyone who shared family photographs and stories. The richest source of images, however, was found at the Madison County Historical Society (MCHS) Archival Library, where photographs donated by the Nelson family are stored. The staff of the historical society provided the exceptional service and assistance that I have come to expect from them and will always appreciate.

Writing this book has been on my bucket list ever since I began selling Arcadia books as a book buyer at Southern Illinois University Edwardsville. Retirement from that side of the book trade made writing this book possible. I would like to thank Arcadia Publishing for providing a venue for the preservation of regional histories.

And finally, I thank my personal historian, my husband Mike, for his endless patience, his assistance in proofreading the manuscript, and his support throughout this project.

INTRODUCTION

The cooperative Village of Leclaire was founded in 1890 by Nelson Oliver Nelson, a millionaire businessman and philanthropist. Looking for suitable property to build his new factories and model village, Nelson approached city leaders in several Missouri and Illinois towns near his St. Louis, Missouri, headquarters. He was also looking for a financial incentive. A tract of land with access to water, coal, and transportation was found near Edwardsville, and local businessmen acted quickly to bring Nelson to their doorstep. In less than three weeks, the community raised a fund of $20,000 from individual contributions of $1 to $1,000 to entice Nelson to choose Edwardsville for his enterprise.

City leaders had hoped to locate property inside the city limits of Edwardsville, but when no suitable site of 125 acres could be found, they were confident that the Nelson investment south of town would soon become a part of Edwardsville. Although Nelson fulfilled all the contingencies for construction and job creation in his contract, it would be 44 years before the property was annexed to Edwardsville. Leclaire would remain an independent village from 1890 until 1934. During that time it earned a national as well as international reputation for innovations in business, education, and lifestyle. For those same reasons, the former village was listed on the National Register of Historic Places in 1979.

What separated Leclaire from other company towns or model communities of the era was the vision of N. O. Nelson. As a businessman, Nelson designed a financial model that he hoped would resolve the conflict between labor and capital. As a philanthropist, he was dedicated to improving the everyday life of his fellow man. After studying model towns in the United States and Europe, Nelson founded Leclaire to "give work, promote intelligence, provide recreation, foster beauty and make homes." These were all factors he determined were necessary in order for men to lead fulfilling lives.

Work was the most important of these factors since, to a certain extent, the factories at Leclaire made everything else possible. N. O. Nelson Manufacturing Company was the sole employer in Leclaire. Headquarters remained in St. Louis and other factories were located in Alabama and Indiana, but only Leclaire was built with a companion village. Nelson tried to make working conditions and company policies advantageous to the workers. For the Leclaire factory buildings, Nelson hired architect E. A. Cameron to build modern facilities that would provide natural light and ventilation in summer and heated floors in winter. Every effort was made to guarantee the safety of the workers, including the installation of a fire suppression system. The grounds of the handsome ivy-covered brick buildings were landscaped with beds of flowers and trees for shade. In 1894, a national reporter called the buildings "the ideal perfection of buildings for man to labor in."

More important than the buildings were the company policies designed to protect the financial stability of N. O. Nelson Manufacturing Company employees. Workers could earn a share of the profits and have a voice in the company. By instituting profit sharing, Nelson gave the employees a pride of ownership that resulted in a supportive workforce with relatively few labor problems.

Workers also had reasonable hours and competitive wages. A provident fund provided for pensions and sick leave as well as widow pensions if a worker died, whether or not the death was related to his employment.

One of the earliest buildings in Leclaire was the large Club House, which provided furnished rooms for workers from St. Louis until company housing was available. The Club House also provided space for the community's first educational endeavors. It contained a well-stocked library and meeting space for the Leclaire Self Culture Club, which featured weekly educational lectures by professors from Washington University or visiting guests of N. O. Nelson. By 1892, a morning kindergarten using the Fröbel model was offered at the Club House, with classes for older students in the afternoon. Three years later, the Club House was moved to make room for the School House that was built to accommodate large gatherings and could be divided into smaller spaces for classes and club meetings. In the ten years following construction of the school, there was a series of educational experiments including an industrial school, college, night school, and an academy. In these early days of Leclaire, the classes were offered free of charge or as part of a work-study program. The most successful and longest lasting of all the educational endeavors was the kindergarten. This two-year program was free to everyone, including Edwardsville children, until 1931, when for financial reasons the company started charging $5 per month to all except the children of employees. Nelson Manufacturing operated the kindergarten until 1934, when the facility was sold to the Edwardsville School District for a nominal fee.

Construction of the residential portion of Leclaire began immediately after the village was founded in June 1890. Julius Pitzman, the innovative landscape architect who laid out the first lots in Leclaire, set them up with a number of protective covenants. The plan provided for wide curvilinear streets, large lots, and a deed restriction that limited the properties to residential or educational purposes only. The company paved the roadways, provided electric streetlights, installed sidewalks, and planted hundreds of trees along the streets of Leclaire. Later sections of Leclaire were laid out with a conventional grid design and smaller lots but still included the deed restrictions. Many of the homes were built by the company and then sold at near cost to Nelson employees in order to encourage home ownership. If a worker became ill and could not make his mortgage, payments were suspended until after he returned to work. The homes were offered in a variety of designs, and no two dwellings were alike. These predominantly Victorian cottages came with electricity and running water. Residents could also purchase an empty lot and build the house themselves if the architectural design met company standards.

Recreation was an important feature of Leclaire. The company provided sports facilities for baseball, tennis, and later, football. A bowling and billiards hall was constructed, and there was a lake for boating, swimming, fishing, or ice-skating in winter. Leclaire Park was furnished with boathouses, men's and women's bathhouses, and a large pavilion. Residents organized dances, hayrides, spelling bees, and other activities, and the company sponsored a band that played regularly at entertainments in the village or in Edwardsville. Like the educational functions at the Club House and School House, the recreational facilities at Leclaire were open to all, and were often a destination for residents of Edwardsville or even St. Louis.

The last of the factors Nelson deemed important for a satisfying life concerned the environment. Nelson knew about the importance of healthy living. He valued the beauty and cleanliness that could be found in the country, and encouraged all Leclaire residents to beautify their homes and gardens. Nelson led by example, tending his own garden, and a company greenhouse provided free flowers. Residents were encouraged to enter competitions for the most beautiful yards. Leclaire was laid out so that the entire village had a parklike setting still evident today.

All of the programs offered by the company were available to employees and residents, but none were mandatory. The decision to participate in company plans was entirely up to the individual. Residents of Leclaire could work for Nelson Manufacturing or elsewhere. Nelson workers were under no obligation to live in Leclaire.

These benefits made Leclaire unique from other company towns. But there were also individual instances where the company showed compassion and care for the employees. It closed the factories

and hired excursion trains to take workers and their families to St. Louis for a day during the 1904 St. Louis World's Fair. Nelson would occasionally place extra cash in each pay envelope to make life easier for the workers. When Nelson instituted a program the men did not agree with, they talked it out; and as often as not, Nelson would reverse himself. He was a complicated man: a capitalist who believed in free enterprise, but also a socialist, a follower of the golden rule, and a patriot who served in the Civil War.

Nelson Oliver Nelson was born September 11, 1844, in Lillesand, Norway. Two years later, his family immigrated to America with a group of 80 neighbors and friends. Nelson's mother died of typhoid in New Orleans before reaching their destination, a fact that would later influence Nelson's philanthropic decisions. He was raised in an immigrant community of farmers in northwestern Missouri, where he spoke Norwegian at home and English at school. At 16, Nelson joined the Union army, where he was trained as a bookkeeper. He served four years, keeping the company books and preparing correspondence for officers. After the war, he entered the wholesale grocery business in St. Louis, then moved on to work as a retail storekeeper for five years. Neither of these ventures was financially successful, but they helped lay the groundwork for Nelson's career. His next employment venture was as a bookkeeper for a wholesale plumbing supply and hardware company in St. Louis. For Nelson, it was the start of what would be a very successful profession. Within a short time, he became a partner and then sold out to start his own wholesale plumbing supply company in January 1877. At the end of the first year, Nelson shared several hundred dollars in profit with his few employees, a practice that would continue informally for a number of years.

By 1882, despite a national economic depression, annual retail sales at Nelson Manufacturing exceeded one million dollars. Wanting to do more for his St. Louis employees, Nelson formalized his profit sharing efforts in 1886 and expanded his philanthropic efforts to other areas of what he called "social betterment." He began by providing educational and recreational opportunities for his employees and founding Fresh Air Missions that provided free weekly excursions on the Mississippi River during the summer months for St. Louis tenement mothers and their children. Nelson believed that the fresh air would be beneficial for the children.

Nelson became an international leader in the fields of cooperation and profit sharing, exchanging social theories with others around the world while expanding his business. He would name his experimental village after the Parisian profit-sharer, Edme-Jean Leclaire, but there were many others that he visited who provided ideas and inspiration. Although Leclaire was not Nelson's only social experiment, it is considered his most successful endeavor outside of business and the most visible today. His other major efforts for social betterment included a chain of cooperative grocery stores in New Orleans that was eventually gifted to the employees, a kindergarten for African American children in Bessemer, Alabama, and a home for consumptives in Indio, California.

Nelson's Village of Leclaire would become known nationally as a great experiment. It was described in the *New York World* on numerous occasions. Reporter Nellie Bly in 1894 wrote at length about the model town where the "labor question is solved and everybody [is] happy in a little village near St. Louis." The *Los Angeles Times* also regularly reported on N. O. Nelson, as did the *Chicago Daily Tribune* and many other publications. In a speech at Leclaire's 15th anniversary celebration, Nelson said, "Leclaire extends to you a wide open hospitality, and bids you enjoy today the ease and comfort and beauty and inspiration which we enjoy every day." More than a century later, the invitation still stands. You are invited to come learn about Leclaire's history and consider the lessons of cooperation that could be of value to future generations.

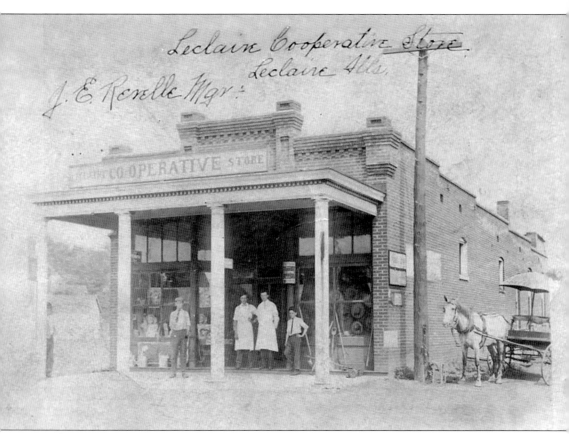

Nelson established the Leclaire Co-operative Store in 1892 as a way for Leclaire residents and workers to save money on their grocery purchases. The store was located just outside Leclaire, at what is now the corner of Wolf and Leclaire Streets. Prices were comparable to local groceries, so savings were only realized by shareholders. One share per family could be purchased at a cost of $25. At the end of each year, shareholders were paid a dividend on their share plus a percentage of the amount they spent at the store during the past year. When the cooperative was sold in 1933, shareholders received $75 for their $25 investment. The above photo postcard was mailed in 1910. (Courtesy of Kathy Danielsen.)

One

N. O. NELSON MANUFACTURING

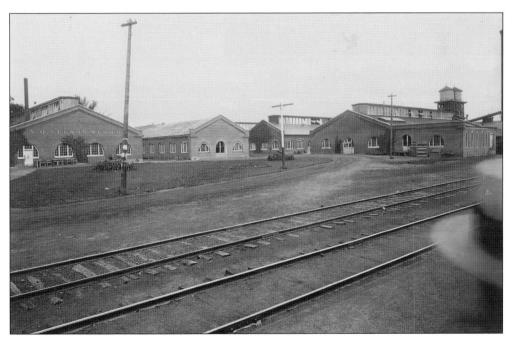

This photograph of N. O. Nelson Manufacturing Company shows several of the factory buildings around 1895. Nelson referred to the various industries in Leclaire as shops: Machine Shop, Marble Shop, Brass Shop, Finishing Shop, Bath Tub Shop, Copper Shop, Cabinet Shop, and Carpenter Shop. Although all the shops were owned by Nelson Manufacturing, in later years some were set up independently for bookkeeping purposes. The Machine Shop, known as Bignall and Keeler, was the company N. O. Nelson left in 1877 to found his own firm. Several years later, he bought Bignall and Keeler and made it part of N. O. Nelson Manufacturing Company. The Brass Shop became the Edwardsville Brass Company, and the Marble Shop became N. O. Nelson Marble Works. (Courtesy of MCHS.)

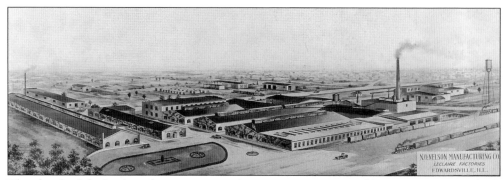

This sketch of the Leclaire factories was used in various company publications promoting both the business and the village. The structures just beyond the main factory buildings included a barn with a stable and a warehouse. (Courtesy of MCHS.)

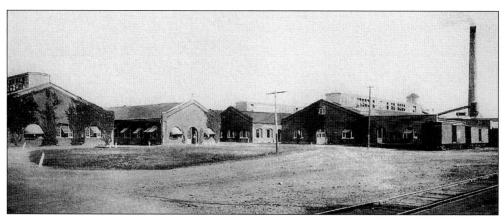

The postcard view of the Leclaire factories shown here was taken in the 1890s before ivy completely covered the buildings. From left to right are the Brass Shop, Finishing Shop, Marble Shop, and Machine Shop. Leclaire factory buildings still in existence today are home to the Historic N. O. Nelson Campus of Lewis and Clark Community College. (Courtesy of Stephen Hughes.)

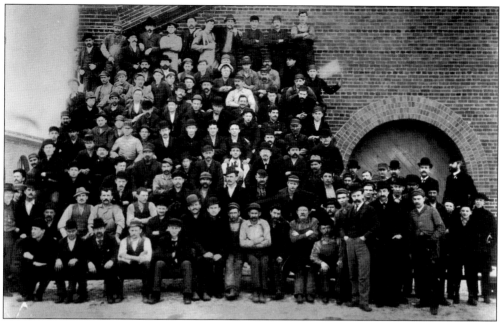

Managers, laborers, machinists, and carpenters pose in this undated image from the early days of Leclaire. Many of the workers were skilled European craftsmen. Others were longtime Nelson employees from St. Louis in search of better living conditions in the country. There were also local hires and men who came to Leclaire from a distance after learning about the village from newspaper accounts. (Courtesy of Robert Hyten.)

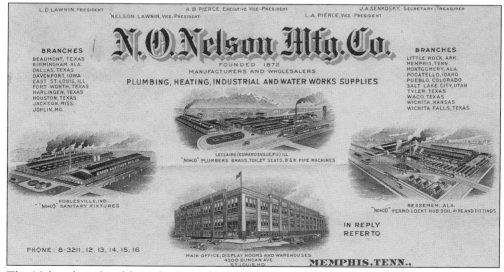

This Nelson letterhead from the Memphis branch of the N. O. Nelson Manufacturing Company is from the 1930s. It pictures the manufacturing facilities at Leclaire, Illinois; Noblesville, Indiana; and Bessemer, Alabama, as well as the St. Louis, Missouri, headquarters. The letterhead lists 20 branch offices, but there were others, including Los Angeles, California. (Author's collection.)

N.O. Nelson Marble Co.

St. Louis, Mo. Edwardsville, Ill.

Interior Marble Work

Tile Floors Tile Wainscoting

Contracts being executed in Edwardsville:

Bank of Edwardsville Building U. S. Post Office Building

A partial list of the larger contracts executed in recent years:

ST. LOUIS, MO.
Liggett Bldg.
Wright Bldg.
New National Bank of
 Commerce Bldg.
Marquette Hotel
Buckingham Club
Frisco Hospital
St. Luke's Hospital
Laclede Gas Co. Bldg.

NORFOLK, VA.
St. Vinc. de Paul Hospital

MOBILE, ALA.
Citizens National Bank

E. ST. LOUIS, ILL.
First National Bank
Southern Illinois Natl. Bank

NEW ORLEANS, LA.
Passenger Station
New Orleans Term. Co.

JACKSON, MISS.
State Capitol Bldg.

MEMPHIS, TENN.
Gayoso Hotel
Goodwyn Institute

ORANGE, TEXAS
Lutcher Memorial Church

HOUSTON, TEXAS
Rice Hotel

AUSTIN, TEXAS
Scarborough Bldg.

EL PASO, TEXAS
Guarantee Tr. Co. Bldg.

DENISON, TEXAS
M. K. & T. R. R. Station

MUSKOGEE, OKLA.
Barnes Bldg.
Severs Hotel

KANSAS CITY, MO.
Westport High School
Sharp Bldg.

OMAHA, NEB.
Brandeis Bldg.
Keeline Bldg.
City Natl. Bank Bldg.
Brandeis Theatre

DES MOINES, IA.
Hippe-Polk Bldg.
Iowa Loan & Tr. Co. Bldg.

**COLORADO SPRINGS,
 COLO.**
Burns Theatre
Mining Exchange Bldg.

DAVENPORT, IA.
Independent High School
Blackhawk Hotel

SEATTLE, WASH.
Washington Hotel
Leary Bldg.

Nelson took out a full page advertisement in a 1914 program booklet for the Vereinsbund Conference in Edwardsville. It shows the variety of customers and projects handled by the Marble Shop. (Courtesy of Joan Evers.)

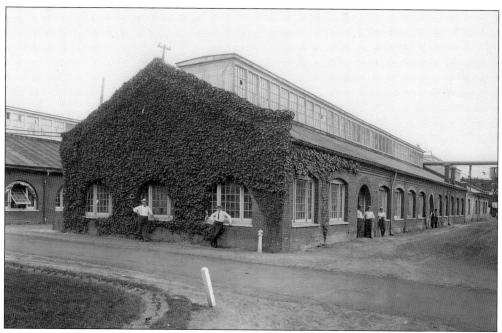

From left to right, George Lewis, Roland Van Hyning, William Held, W. H. West, and Tom Walton stand outside the Marble Shop at Leclaire in the image above. Below is the interior of the shop. Items regularly manufactured at the Marble Shop included wall and floor tiles, marble staircases, lavatories, and vanities, as well as custom installations. (Both, courtesy of MCHS.)

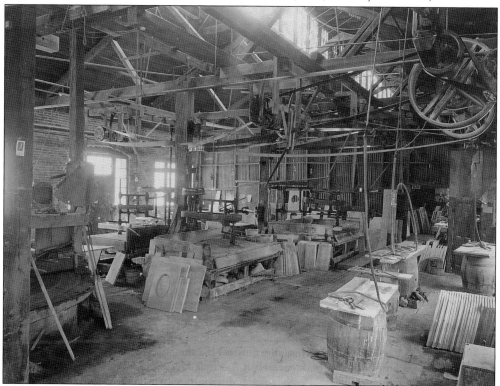

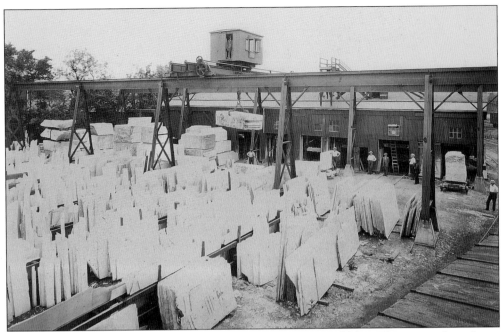

The marble yards on the south side of the factory buildings could be a dangerous place. In an accident in 1903, a large piece of marble was being moved when it slipped, crashing onto a freight car with such force that it cut the car in two. Men working nearby fortunately realized the impending disaster and were able to avoid injury. (Both, courtesy of MCHS.)

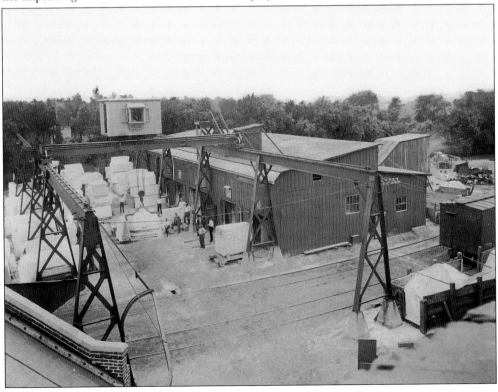

Above, from left to right, are Thomas Walton, Henry Dohle, unknown, and Edward McLean Sr., who were all Brass Shop employees. Walton, an English immigrant, began work with Nelson Manufacturing in 1892 and retired in 1942 as supervisor of the Brass Shop. Henry Dohle was a brass worker, finisher, and pattern maker employed for 57 years before retiring. McLean, an Irish immigrant, came to work in Leclaire in 1896. He was a foreman in the buffing and polishing department when he died in 1940. Below is a view of the interior of the Brass Shop. Although most production was of plumbing related materials, the shop also did custom work. The production of flag poles is just one example of a product not related to the plumbing industry. (Above, courtesy of Edward McLean Sr. family; below, courtesy of MCHS)

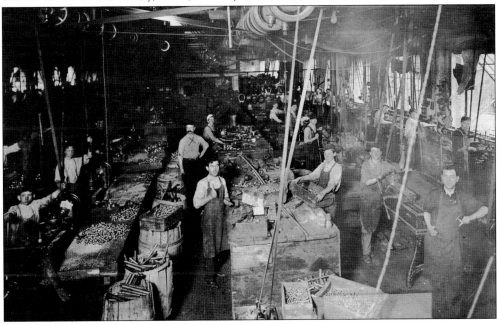

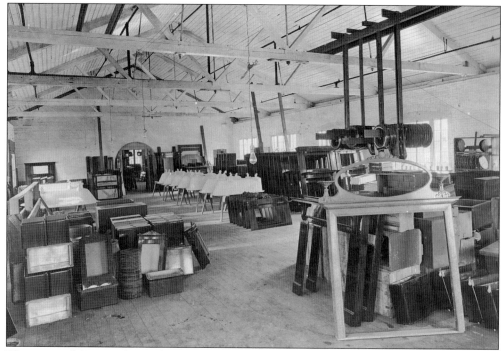

This view of the Finishing Shop shows a variety of manufactured items in the end stage of production. To the right at the rear are stacks of fireplace mantels and mirror frames; white bathtubs are piled on sawhorses at the center of the frame; and to the left are glass-front wall cabinets. The company produced millwork for the houses it built in Leclaire and did custom work for area residences, churches, and businesses. (Both, courtesy of MCHS.)

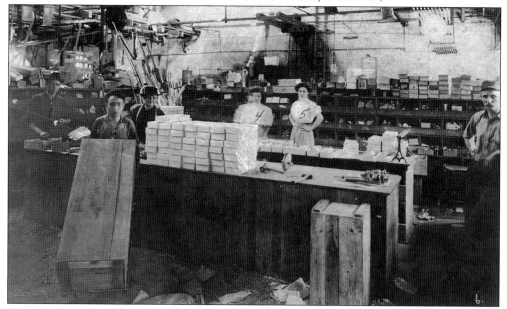

Although most female employees held clerical positions, there were a few who worked other jobs, like these women in the packing room. The woman on the right is identified as Mae McLean, dating the image to before July 1915, when McLean married Joseph Agles. (Courtesy of MCHS.)

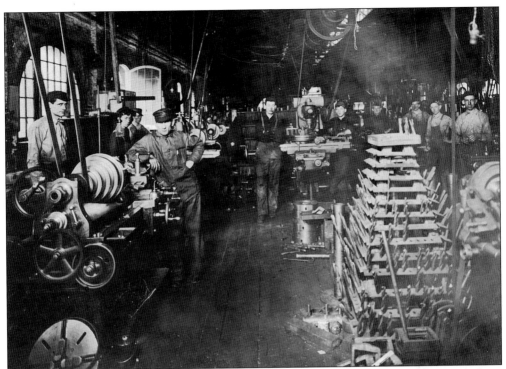

Here are two more interior views of the Nelson shops. Although the company did everything possible to make the shops safe given the technology of the time, accidents were frequently reported in the local newspapers. Most involved damage to or loss of fingers, but there were also reports of eye injuries. Employees were paid during any convalescence. (Both, courtesy of MCHS.)

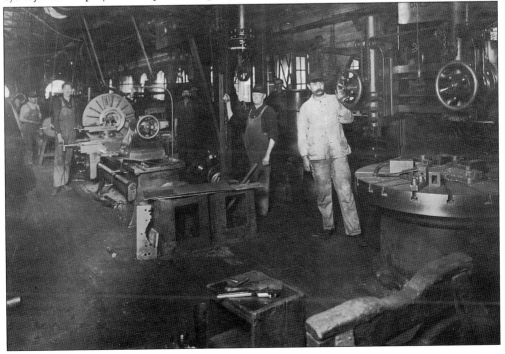

These sample pages from *Souvenir World's Fair St. Louis 1904* published by N. O. Nelson Manufacturing Company show the primary facilities of the company as well as some of their larger contracts. As a member of the world's fair committee, Nelson hosted dignitaries from around the world at his home in Leclaire during the fair. (Both, author's collection.)

FESTIVAL HALL AND CENTRAL CASCADES
Festival Hall covers two acres and is 200 feet high. The central cascade has a fall of 90 feet.

PALACE OF TRANSPORTATION
Dimensions, 525 by 1200 feet, about 15 acres. Cost $696,000. Plumbing fixtures used in these buildings made by the N. O. Nelson Mfg. Co.

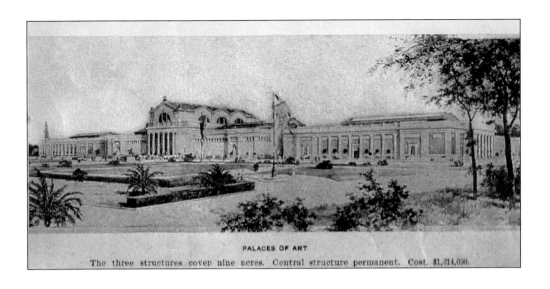

PALACES OF ART
The three structures cover nine acres. Central structure permanent. Cost, $1,014,000.

In addition to the buildings shown here, the souvenir booklet also featured pictures of St. Louis' Union Station, McKinley High School, and the Planter's Hotel. Other world's fair buildings where Nelson obtained contracts for plumbing included the Missouri State Building, Iowa State Building, Palace of Agriculture, and Palace of Horticulture. (Both, author's collection.)

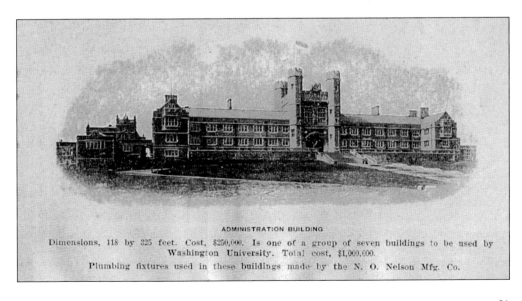

ADMINISTRATION BUILDING
Dimensions, 118 by 325 feet. Cost, $250,000. Is one of a group of seven buildings to be used by Washington University. Total cost, $1,000,000.
Plumbing fixtures used in these buildings made by the N. O. Nelson Mfg. Co.

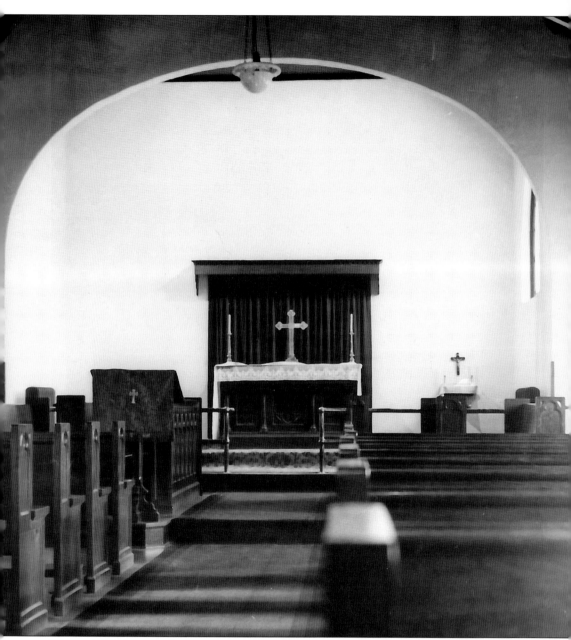

This c. 1920 photograph shows the interior of St. Andrew's Episcopal Church in Edwardsville. Many of the church's furnishings as well as the 1916 cornerstone were made in the Leclaire shops. The pews and brass communion rail were purchased from the Leclaire factories. The altar, made in the Cabinet Shop, was a gift from then vice-president Louis D. Lawnin and his brother Albert Lawnin of St. Louis in memory of their mother who died in 1915, shortly before the church was built. The brass and marble candlesticks on the altar were a gift in memory of Almeria Nelson after her death in 1918. The brass cross behind the altar was also made at Leclaire as was a beautiful wood, marble, and brass baptismal font donated by the Lawnin family. All except the brass communion rail, since replaced with a wooden rail, are still in use today. (Courtesy of St. Andrew's Episcopal Church.)

Two

EDUCATING THE
WORKING CLASS

This photograph of Leclaire School House is a favorite for many area residents. At the far left is Charles Vollentine with his white dog, who appears to be smoking a pipe. On the right is Louis D. Lawnin, N. O. Nelson's son-in-law, who would become president of the company when Nelson retired in 1918. (Courtesy of MCHS.)

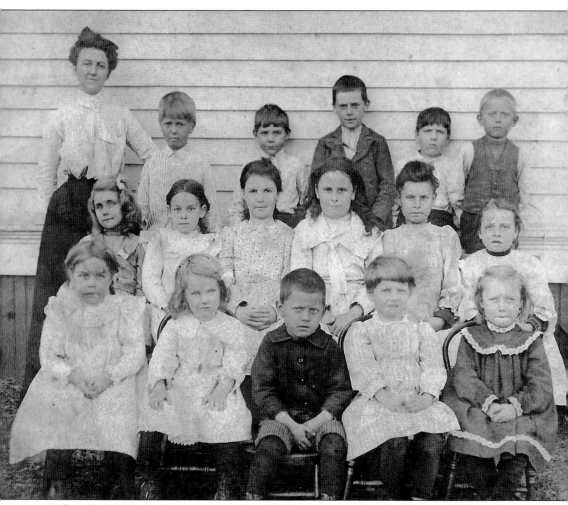

When this 1903 school portrait was taken, Leclaire was a grade school, but would soon change to a kindergarten only, with older students attending school in Edwardsville. Mildred Shaw, pictured in the second row, donated this photograph to the Madison County Historical Museum. She would later become a beloved kindergarten teacher at the school for 25 years. Pictured are, from left to right, (first row) Dora Hallquist, Josephine Lawnin, Louis Lehman, Charlotte Lawnin, and unknown; (second row) Mildred Shaw, Karen Hallquist, Mamie Dillon, Mary Mays, ? Collins, and Lillian Merkel; (third row) teacher Olive Thomas, Nelson Lawnin, unknown, George Dillon, unknown, and William Lehman. (Courtesy of MCHS.)

This undated postcard picturing the Leclaire School House was widely circulated. Former students have fond memories of the school, where handwork, art, music, and exercise were emphasized. The Madison County Historical Society Museum has samples of the school's workbooks, donated by Dolores Howerton Rohrkaste, that illustrate some of the educational crafts practiced by the students. (Courtesy of Stephen Hughes.)

This view of the southwest side of the Leclaire School House shows the billiards hall on the left in the distance. Near the front of the image is an N. O. Nelson Manufacturing Company (NONCO) fire hydrant. The hydrants were probably made at the Nelson foundry in Bessemer, Alabama. In 2010, a few NONCO fire hydrants can still be found in Leclaire. (Courtesy of MCHS.)

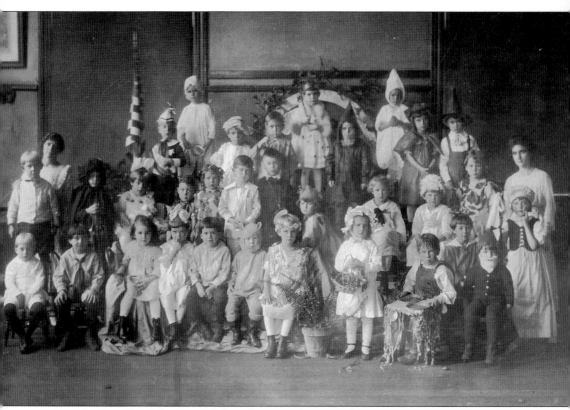

Dorothy Spindler Solter attended Leclaire Kindergarten for two years, from 1919 to 1920, and donated this photograph to the Children's Museum at Edwardsville, located in the former Leclaire School House. Solter is on the right, behind the two little boys in the front row. She is not certain if the photograph was taken at Halloween or for a school play but remembers that a professional photographer came to take the portrait. (Courtesy of Children's Museum at Edwardsville.)

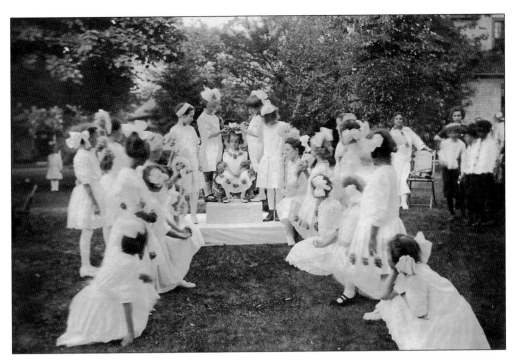

The elaborate costumes and ceremony for the kindergarten graduation program are evident in these photographs from 1913. Above is Frances Lyman of 930 Holyoake Road as she is crowned May Day Queen. Frances continued her education with a bachelor's degree at MacMurray College in Jacksonville, Illinois, and graduate work at the American Conservatory of Music, then in Chicago. Advertisements in the *Edwardsville Intelligencer* in 1934 indicate that she offered lessons in violin, piano, and harmony at her home on Holyoake Road. (Both, courtesy of MCHS.)

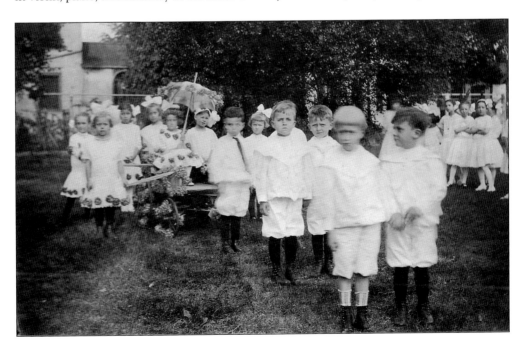

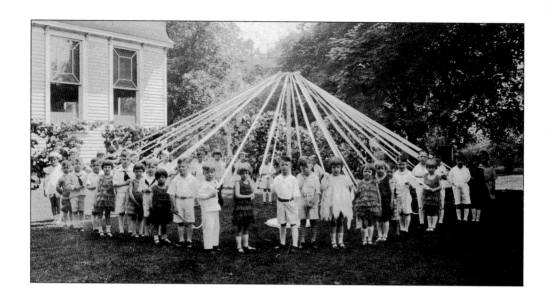

Loretta Stullken described the maypole dance in a 2000 interview: "One of the teachers would play the piano. And they played a special number, some little march. And [we were taught to] go to a certain person, in front of one and in back of another and weave. And when we were finished the maypole was all bound with these colored ribbons. It was beautiful." Some years the students wore costumes like butterflies or flowers. In the 1928 photograph above, the girls are wearing traditional crepe paper dresses. A school picture taken the same day is below. (Above, courtesy of Loretta Pizzini Stullken; below, courtesy of Dolores Howerton Rohrkaste.)

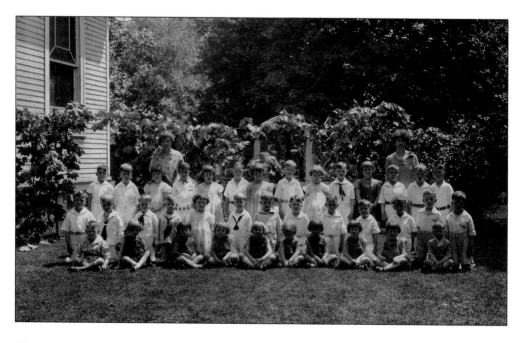

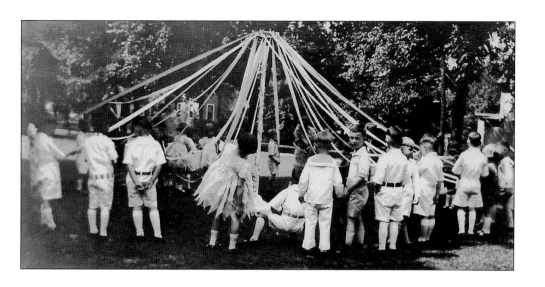

In later years, the Leclaire Kindergarten's May Day celebration was often the graduation program as well. A program from the late 1920s listed a dozen musical numbers, folk dances, and recitations, followed by the traditional maypole dance and presentation of diplomas. The girls wore white dresses made by their mothers from crepe paper. Typically there would be a group portrait showing all the kindergarten children in the two-year program, a maypole dance portrait, and a graduation portrait. (Above, courtesy of MCHS; below, courtesy of Dolores Howerton Rohrkaste.)

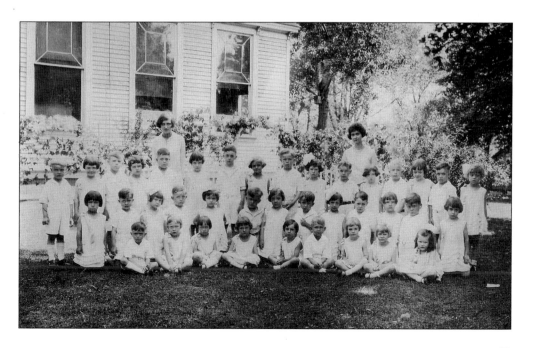

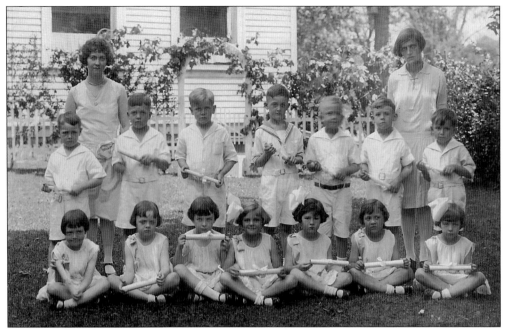

There is quite a contrast between the class of 1929 (above) and the class of 1933 (below). In 1931, the Leclaire Kindergarten was forced to start charging tuition to students who were not the children of Nelson Manufacturing employees. During the Depression, the fee of $5 per month resulted in a greatly reduced class size. (Courtesy of Loretta Pizzini Stullken.)

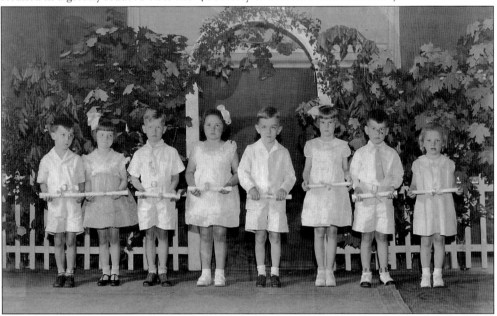

The class of 1933 represented one of the last classes that enjoyed the Leclaire School House as a kindergarten only. Beginning in 1934, the school was sold to the Edwardsville School District. In a major renovation, the school district put a basement with restrooms under the building and created four permanent classrooms. After the fall of 1934, several grades would occupy the building. Betty Lou Kriege is second from left. (Courtesy of Betty Lou Kriege Fodor.)

Three

RECREATION FOR RESIDENTS AND GUESTS

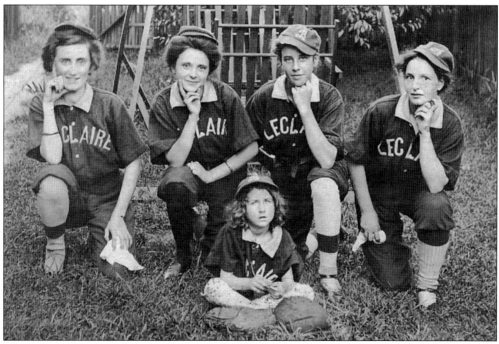

This postcard was made in fun by a group of young women wearing their husbands' Leclaire baseball uniforms. While there were many organized athletic activities in early Leclaire, most of the participants were men. The ladies belonged to music groups, sewing societies, literary clubs, and other organizations. (Courtesy of Stephen Hughes.)

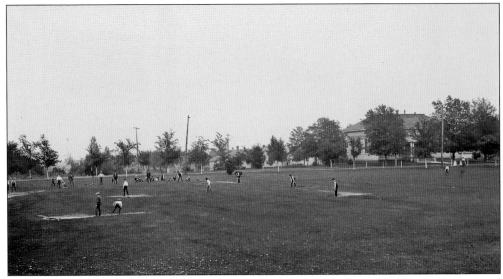

Weekly games of baseball were played in Leclaire against teams from neighboring towns until 1924, when the American Legion field and grandstand were built. The Sunday afternoon games became a nuisance to the neighborhood when the crowds grew larger as the number of automobile owners increased. But the ball diamond and other fields remained open for children and other neighborhood sports enthusiasts. (Courtesy of MCHS.)

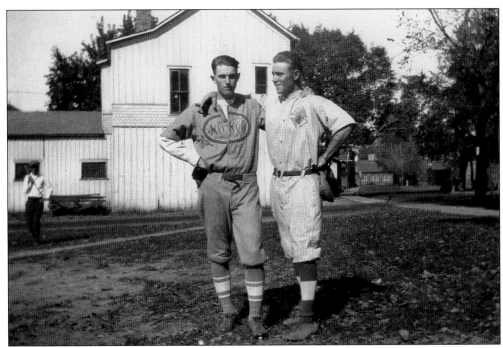

Eppie Shaw (left), in his N. O. Nelson Manufacturing Company (NONCO) uniform, and Joseph Rotter, with the Knights of Columbus team, pose in front of the Leclaire recreation hall. Though playing for opposite teams, the men grew up in homes less than a block apart in Leclaire. The rivalry was a friendly one. (Courtesy of Judy Veith.)

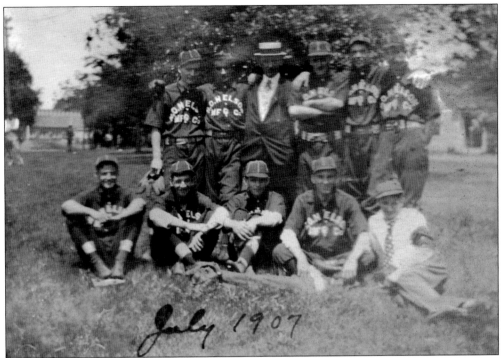

Pictured here are the N. O. Nelson team of 1907 (above) and the Leclaire Blues team from 1909 (below). Other teams that played for the company were the Leclaire Athletics and the NONCOs. Teams fielded players with a wide range of ages. Games against teams from neighboring towns at Leclaire Field would attract hundreds of spectators. (Above, courtesy of MCHS; below, courtesy of Christine Taul.)

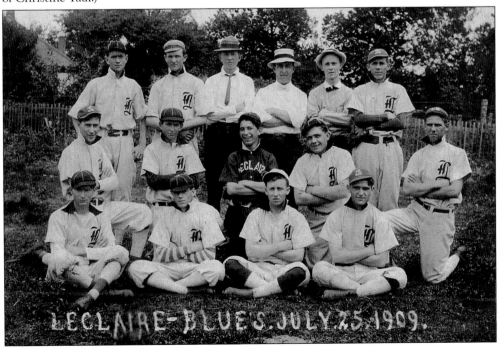

Football in Leclaire was organized in 1897. The Leclaire Tigers played on the same field later used by the Edwardsville High School Tigers in the years prior to construction of the new high school that opened in 1925. Daliso Rizzoli is at left, but the other players are unknown. (Courtesy of Christine Taul.)

Constructed in 1890, the recreation hall featured bowling and billiards as well as meeting rooms. Like the ball fields and Leclaire Lake, the facility was not restricted to employees and residents of Leclaire, so there were a number of leagues that played regularly. The recreation hall was torn down in 1933, shortly before Leclaire was annexed by the city of Edwardsville. (Courtesy of MCHS.)

The Sewing Class met regularly with instructor Mary Koch (front), a dressmaker. In addition to Koch, those identified in this photograph are Bertha Merkle Piper (second row, center) and Laura Eberhart Brown (first row, left). (Courtesy of Friends of Leclaire.)

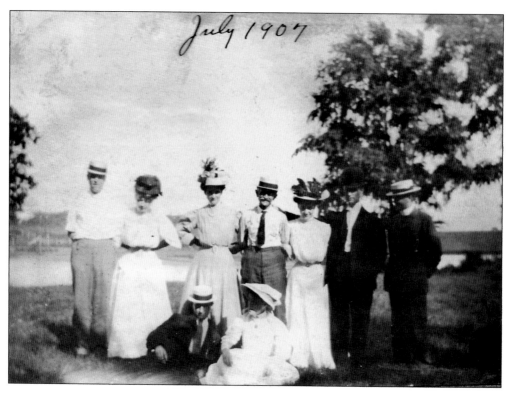

Picnics at Leclaire Park were popular activities. The photograph above shows N. O. Nelson (standing center) with friends and family on an outing in 1907. St. Louis residents often took a train to Leclaire in the summer to spend a day in the country. (Both, courtesy of MCHS.)

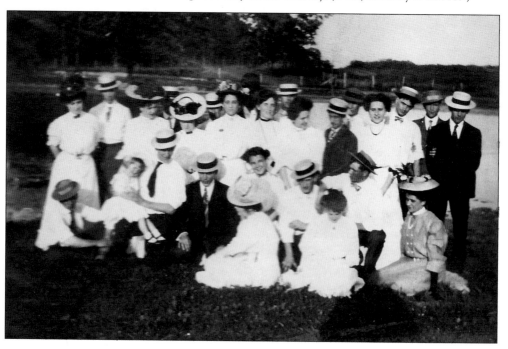

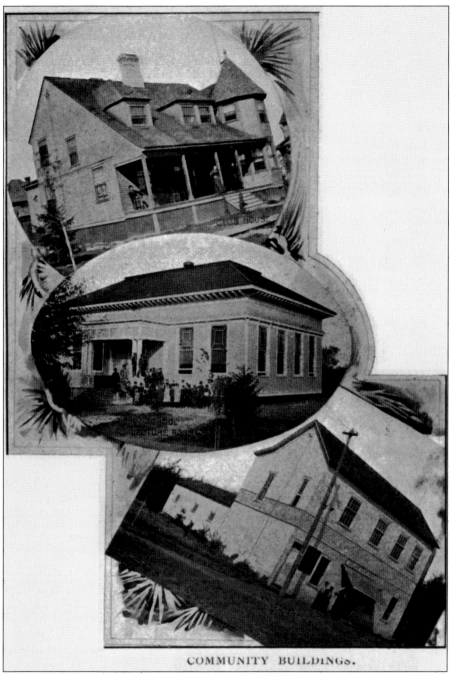

COMMUNITY BUILDINGS.

In 1895, the Edwardsville *Intelligencer* published a special "Industrial Edition" that included this collage of images showing Leclaire's public buildings. It is the only known photograph of the Leclaire Club House (top). Built in 1890, the Club House served as combination hotel, restaurant, rooming house, and community center. The building had a library, meeting rooms, and a well-stocked newspaper rack near the fireplace. The buildings below the Club House in the advertisement are the School House (center) and the Recreation Hall. (Courtesy of MCHS.)

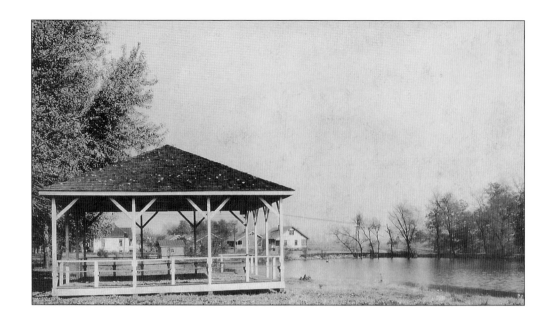

The c. 1910 photograph above shows the bandstand at Leclaire Park. On summer evenings, the park manager, Tom Trigg, would rig boats with Japanese lanterns so sweethearts could enjoy a romantic moonlight ride while the band played on the bandstand. The image below is of the new bandstand built in 1924, with basement restrooms. (Above, courtesy of Neal Strebel; below, courtesy of MCHS.)

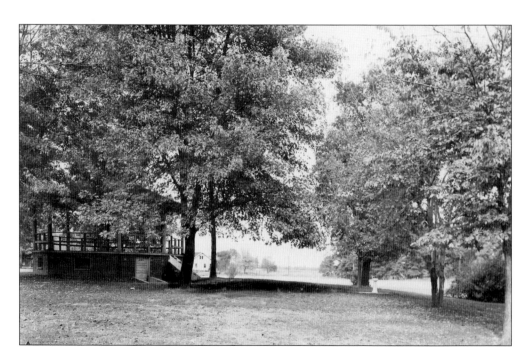

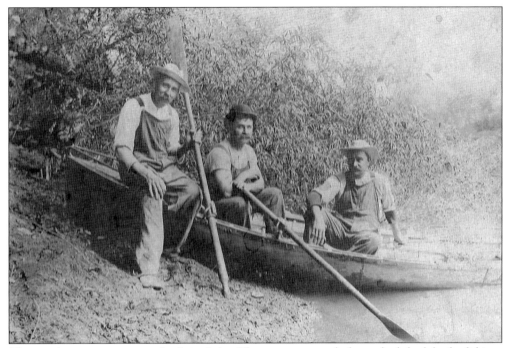

Three unknown men pose at Leclaire Lake. The company regularly stocked the lake for fishing, a practice continued by the Edwardsville Park District today. Although anyone was free to fish at the lake, the company was always on alert for people trying to seine the lake, which was not permitted. (Courtesy of Elizabeth Shaw Stolte.)

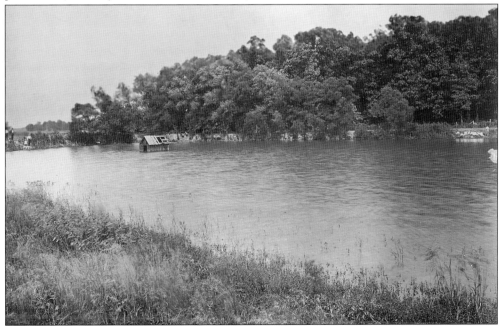

The occasion is unknown, but close-up views of this photograph show dozens of people along the bank on the opposite side of Leclaire Lake. It was a popular place for residents and visitors on hot summer days before air-conditioning was available. (Courtesy of MCHS.)

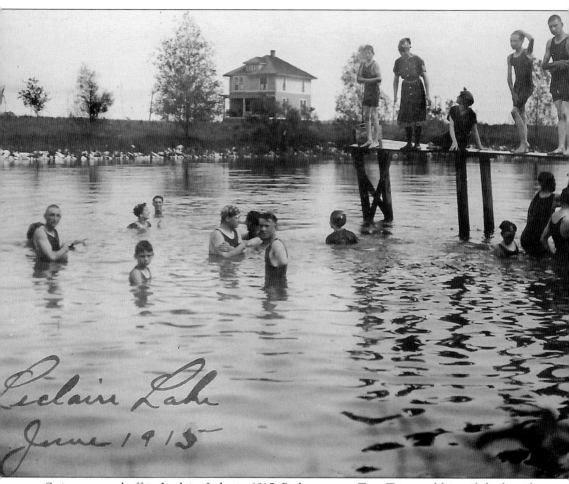

Leclaire Lake
June 1915

Swimmers cool off in Leclaire Lake in 1915. Park manager Tom Trigg and his wife had a side business where they rented bathing suits to Leclaire visitors. The streetcars brought hundreds of city residents to Leclaire in the summer. Some did not own bathing costumes, and others found it more convenient to leave a wet suit in Leclaire rather than carry it back on the train. The house in the background is located on East Avenue. (Courtesy of MCHS.)

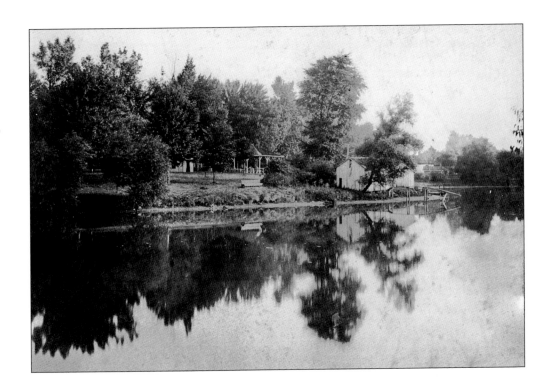

The above photograph of Leclaire Lake shows the bandstand and boathouse as well as the swimming platform, viewed from the south end of the lake looking north. Below is a view of the same features, but from the northern end of the lake looking south. (Above, courtesy of Nancy Hess; below, author collection.)

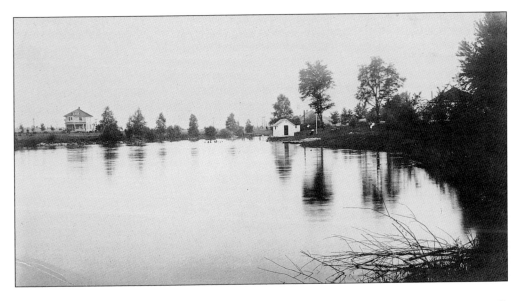

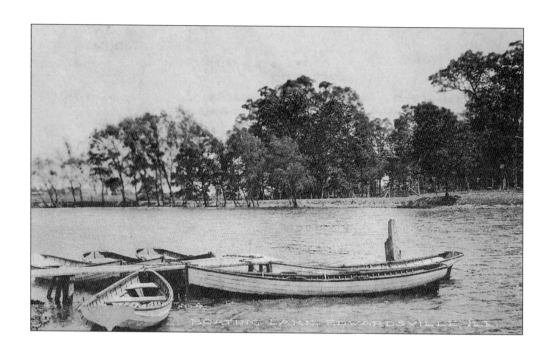

Two popular postcards of Leclaire Lake are shown here. Boats were a popular feature at the lake. Early residents recall that one was always available at the lake in case someone "needed saving." Nelson employees in the Leclaire shops made the boats. (Both, courtesy of Stephen Hughes.)

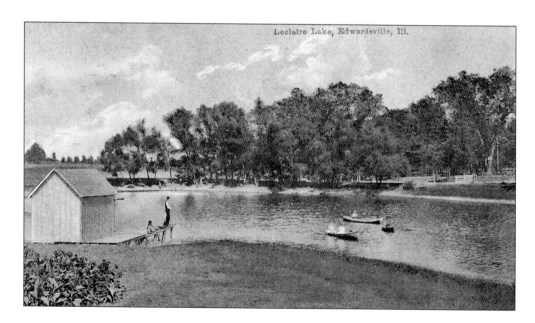

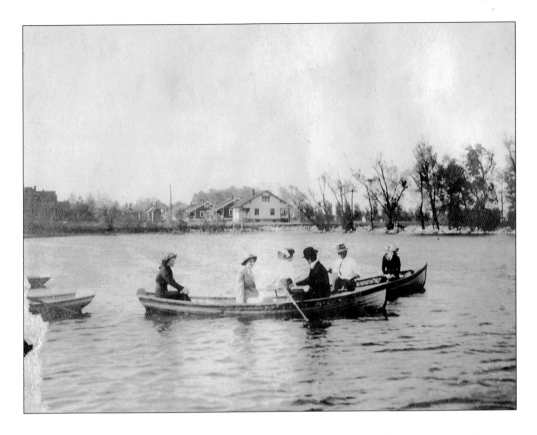

These photographs show Raymond Stullken and Edna Meyer during their courtship at Leclaire Lake around 1916. They are in the center of the image above, Edna in white and Raymond in a dark suit. The courtship was a successful one, and they married on September 7, 1917; the marriage lasted 53 years. (Both, courtesy of Kathryn Stullken Hopkins.)

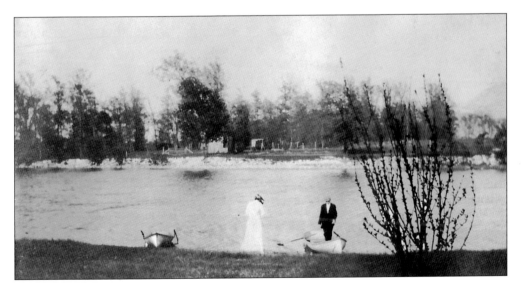

These early photographs of Leclaire Lake were taken when work was being done on the Madison Avenue side of the lake. The company built a dam across a small stream to form the lake in the early 1890s. (Both, courtesy of MCHS.)

Four

THE HOUSES OF LECLAIRE

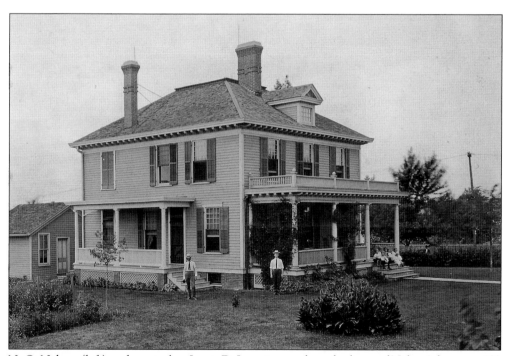

N. O. Nelson (left) and son-in-law Louis D. Lawnin stand on the lawn of Nelson's home at 402 Jefferson Avenue. Nelson continued to live at his home in St. Louis until he built this house in 1897. Larger than the surrounding cottages of Nelson's employees, the elegantly appointed house was a gathering place for academics, leaders in the cooperative movement, and other dignitaries who visited Leclaire. (Courtesy of MCHS.)

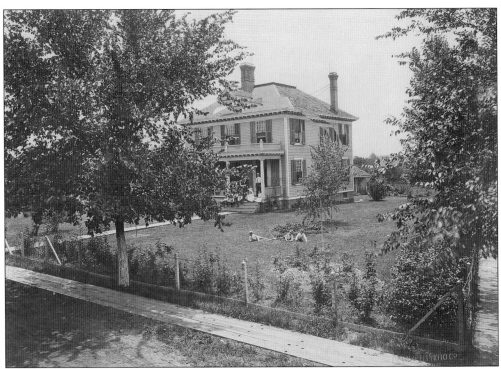

The 1911 view above shows the northwest side of Nelson's home. The image below is from around 1930. Nelson's daughter Charlotte and later his granddaughter Winifred would occupy the house until the mid-1960s. Winifred Burroughs married William Southwick, a designer, in 1952. He removed the original fence, added a circular drive, and replaced the traditional porch with a two story veranda supported by four massive columns. Changes were made to the interior at that time as well, except for the room occupied by his mother-in-law, Charlotte Burroughs. Charlotte lived with her daughter after the death of her husband. Her large front bedroom was a place where she had space to entertain her friends without interfering with the Southwick household. (Both, courtesy of MCHS.)

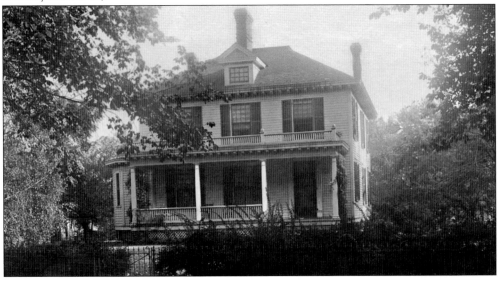

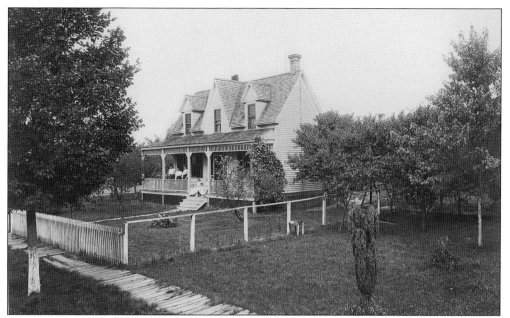

Fred Merkle, foreman of the Copper Shop, purchased this home at 403 Jefferson Road from the N. O. Nelson Manufacturing Company in June 1892 for $1,590. A member of the Merkle family would occupy the house for more than 80 years. The Gothic Revival home is still one of the most striking houses in Leclaire. (Courtesy of MCHS.)

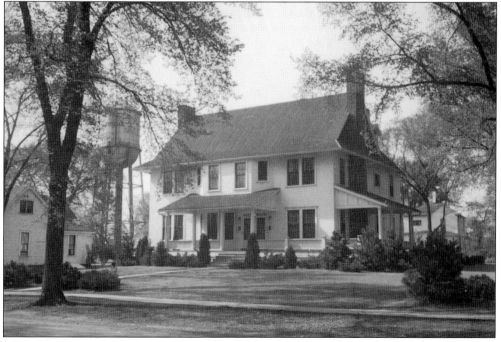

The house known as the Lawnin Mansion is located at 309 Jefferson Road. It was the home of Louis D. Lawnin before he returned to St. Louis to serve as president of the company. In 1922, the company divided the house into two apartments with the upper floor renting for $45 per month and the first floor for $50 per month. (Courtesy of MCHS.)

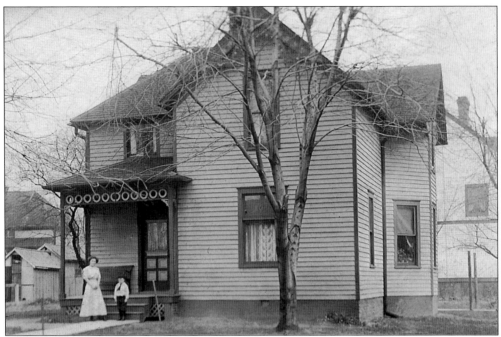

William Shaw, who worked for Nelson in St. Louis before transferring to Leclaire in 1893, was superintendant of the Machine Shop and on the board of directors of the company. Pictured above are two of his seven children, Laura and Kenneth Shaw, in front of their house at 409 Jefferson Road. Below is a 1911 image of the Shaw home, after the addition of a large front porch. The company took the photograph. (Above, courtesy of Elizabeth Shaw Stolte; below, courtesy of MCHS.)

310 Jefferson Road was the home of William Raymond when this photograph was taken. Raymond is standing on the sidewalk and his twin girls are on the steps with other children. Louis Lawnin is leaning on the porch rail at left. In the background is the home of the Pius Rotter family at 811 Holyoake Road. (Courtesy of MCHS.)

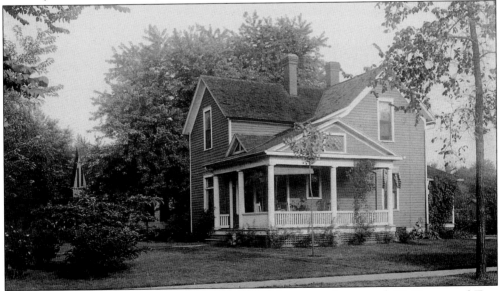

Caleb Bartlett of the Cabinet Shop purchased this home on the corner of Jefferson and Troy Roads in 1893 for $1,524. An industrious employee, during the few years he was in Leclaire, Bartlett was promoted several times. He was president of the Madison County Sunday School Association and played in the Leclaire Band. This *c.* 1911 image was taken after Bartlett sold the house. (Courtesy of MCHS.)

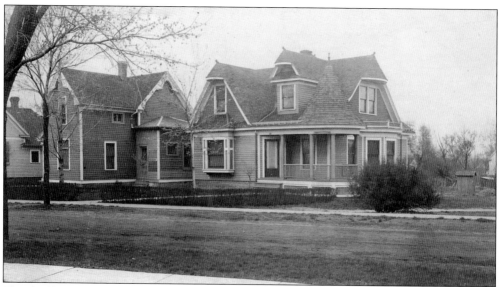

The dwelling on the right at 716 Hale Avenue was built for Erwin and Emma (Rizzoli) Sehnert in 1909. The house plans were purchased from Daverman and Sons, an architectural firm that published a catalog of designs but also advertised through ladies' magazines. The house is listed in the catalog as Modern Colonial No. 18. It is only a few doors away from the childhood home of Emma Sehnert. (Courtesy of MCHS.)

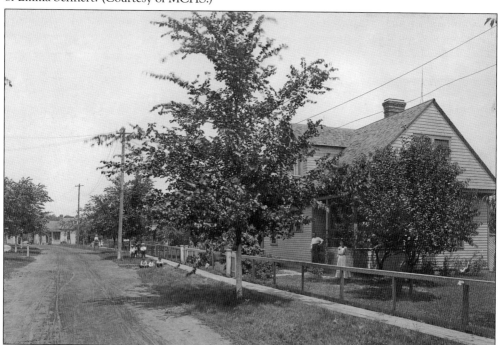

Located on the corner of Hale Avenue and Jefferson Road, the house above was built in 1891. In July 1893, after the death of the original owner, it was purchased by an Italian cabinetmaker, Giuseppe (Joseph) Rizzoli and his wife, Clementina. Several Rizzoli children built homes near their parents: Emma at 716 Hale Avenue, Joseph Jr. behind his parents at 513 Jefferson Road, and Daliso at 1024 Longfellow Avenue. (Courtesy of MCHS.)

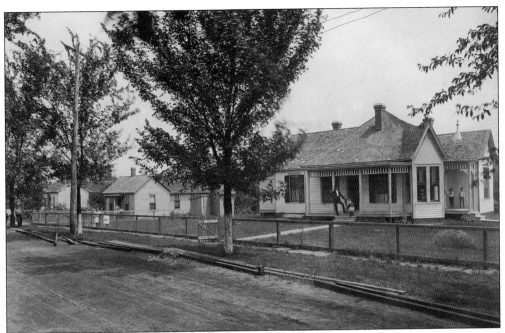

This beautiful Victorian house on the corner of Hale Avenue and Jefferson Road was constructed in the early 1890s but rebuilt by the company 30 years later. The house currently located at 802 Hale Avenue was considered a "modern" bungalow when built. There is no resemblance between the house pictured here and the rebuilt house. (Courtesy of MCHS.)

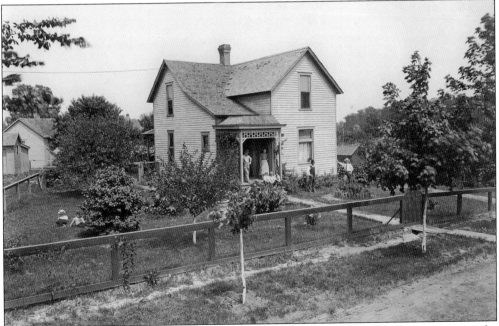

This house at 812 Hale Avenue was the home of Joseph Miller and family, who were among the first families to move into Leclaire. It is believed that this home was a farmhouse already on the property when Leclaire was platted. Miller was active in organizing the cooperative store and often played Santa for the children of Leclaire. (Courtesy of MCHS.)

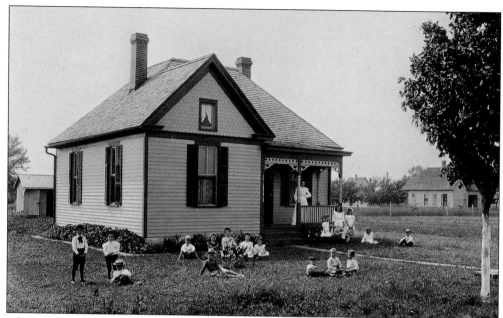

Edward Choate, a machinist for the Nelson Company, paid $1,262 for this home in January 1906. The Choates became known locally in 1897 when their daughter Edith, aged 15, tried to elope. Her father tracked Edith and her young man to St. Louis, Clayton, and Belleville over four days. The couple finally returned home, unable to find a justice who would marry them. The next month, her father relented and allowed them to marry. (MCHS.)

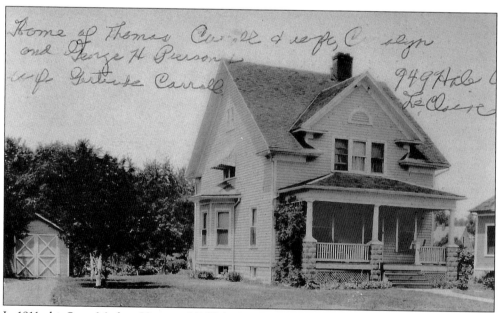

In 1911, this Sears Modern Home at 949 Hale Avenue was built for Thomas and Carolyn Carroll. In July 1912, Thomas died. His widow, Carolyn, resided in the home for many years with her daughter and son-in-law, Gertrude and George H. Pierson. (Courtesy of Friends of Leclaire.)

George Sr. and May Moorman are pictured above on the porch of their home at 303 Holyoake Road (later 929 Holyoake Road). Moorman began working for Nelson as a machinist in the Bignall and Keeler division in 1899, rising through the ranks to retire 56 years later as division manager. After the death of his first wife in 1941, he married Mabel Allen in 1945. Mabel grew up across the street from the Moorman house at 926 Holyoake Road. The small Victorian house below was built for John S. and Mary Alice Allen and their five children in 1907. After their marriage, George and Mabel Moorman made their home at 926 Holyoake Road. (Above, courtesy of Betty Lipe; below, courtesy of Carol Ferry.)

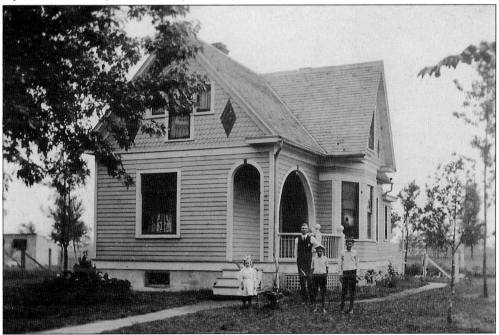

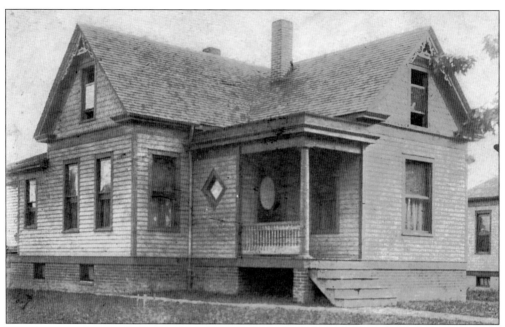

This house at 918 Holyoake Road was built for John Staaf when he married in 1907. Prior to building this house, he had two houses constructed on an adjoining lot. The receipt below is for the houses he built at 910 and 914 Holyoake Road in 1904. A 1910 tax notice shows that Staaf paid $9.35 in taxes on his home at 918 Holyoake Road and $19.80 for the two rental houses at 910 and 914 Holyoake Road. (Both, courtesy of Roger Buchta.)

This one-story duplex at 915–917 Holyoake Road built by John Stolze in 1904 was the only building of its kind in Leclaire. It was evidently constructed as an investment property, and one of the earliest tenants was the Joseph and Adelia Gilmor family. Joseph, a former banker, worked for a short time as a bookkeeper in the cabinet mill. After his death in 1924, Adelia purchased the duplex, where she would reside until her death in the late 1940s. (Courtesy of Ed Kane.)

This home at 900 Holyoake Road is at the corner of a well-travelled alley leading to Leclaire Lake, just a block away. The exact construction date is unknown because the company did not sell the house until 1914, when Charles and Mamie Glass purchased it. They had occupied the house since 1909. Charles was a talented musician often mentioned in the local newspaper. Two of his brothers, Reuben and William Glass, also lived in Leclaire. (Courtesy of MCHS.)

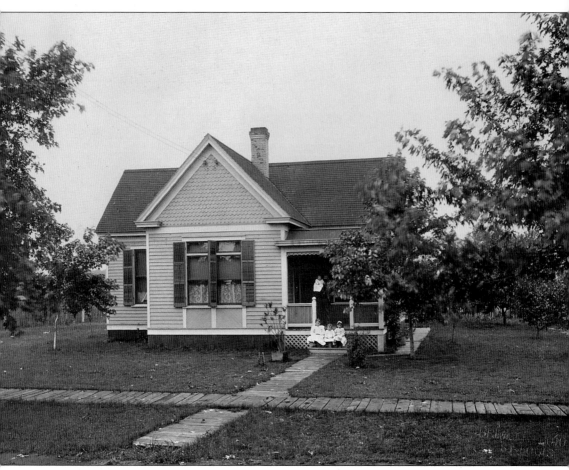

This home at 839 Holyoake Road was purchased for $1,217 by William B. Thomas in 1893. Thomas began working for Nelson in 1889 and was one of the first to settle in Leclaire. He was active in the social life of the village and was the popular leader of the Leclaire Band. In the community's early years, he was foreman of the Varnish Shop, but eventually left the company to work as a musician and music teacher in Edwardsville. He later became the property assessor for Edwardsville. The above image taken in 1911 shows members of the John Retzloff family, who purchased the house from Thomas sometime before 1908. Retzloff and his sons were coal miners. On March 22, 1927, 74-year-old John Retzloff was decapitated near the Leclaire Yards as he gathered coal. He was hard of hearing, and newspapers speculated that he did not hear the oncoming train. (Courtesy of MCHS.)

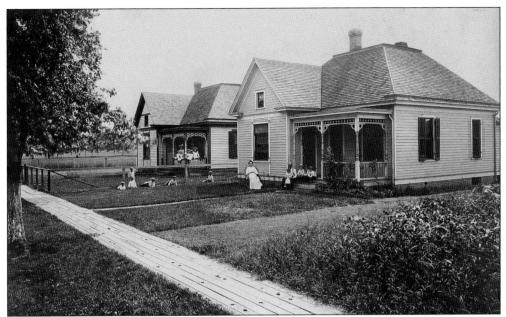

Designed by architect C. D. Hill, 853 Holyoake Road was the first Leclaire home of William and Rose Kennedy, who later built a house on Emerson Avenue. When this home was built in 1899 William was foreman of the Varnish Shop. The wooden sidewalks shown here were laid out in 1890, but later replaced with granitoid walks. (Courtesy of MCHS.)

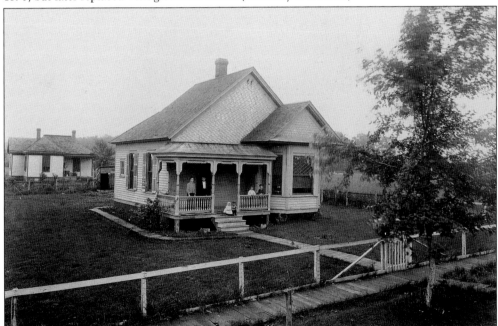

According to the 1908 city directory, 840 Holyoake Road was the home of newlyweds Arthur and Emma Wotier. In February of that year, the newlyweds received a series of letters threatening to kill Arthur if he didn't leave Emma. Front page reporting of the situation appears to have put an end to the letters, assumed to be from one of Emma's former suitors. The house had a long list of tenants, and it is uncertain who is pictured here. (Courtesy of MCHS.)

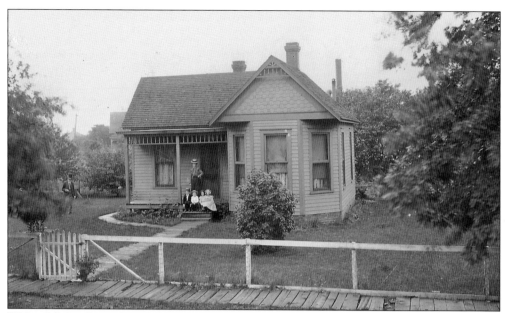

Walter McGrath purchased this home at 820 Holyoake Road in 1906 for $1,100. Within a few years, he sold the house and moved to Wolf Street, just outside Leclaire, where he and his wife ran a saloon and boardinghouse. There were no alcohol sales in Leclaire. (Courtesy of MCHS.)

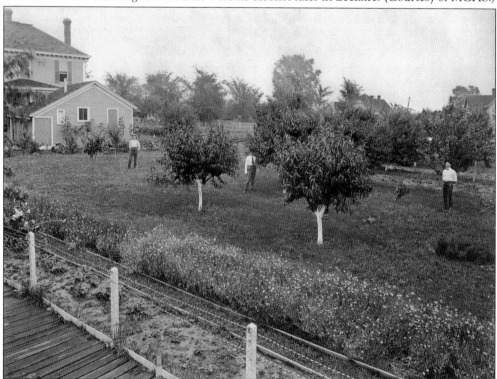

This orchard was located behind N. O. Nelson's house. Fruit trees and gardens were common in Leclaire. Older residents always mention what kind of tree was in their yard, because the company planted a fruit tree on every lot. (Courtesy of MCHS.)

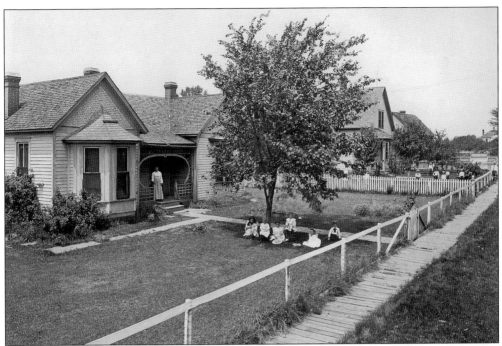

Images of the two houses shown here were often used in publicity releases about Leclaire, beginning in the early 1890s. They were featured on postcards and appeared in national publications. John Tabor, who worked in the Marble Shop, was the owner of 821 Holyoake Road (above). Charles Vollentine moved into his new house at 826 Holyoake (below) in October 1892. Vollentine was a carpenter and built custom furniture to fit the octagonal shape of his living room. (Both, courtesy of MCHS.)

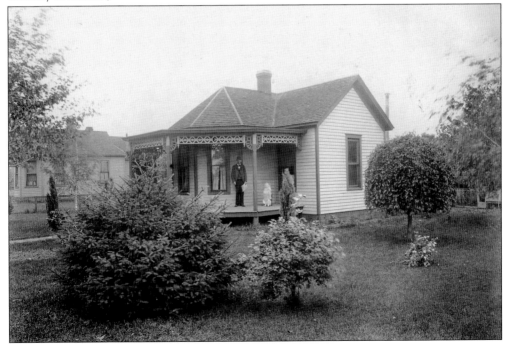

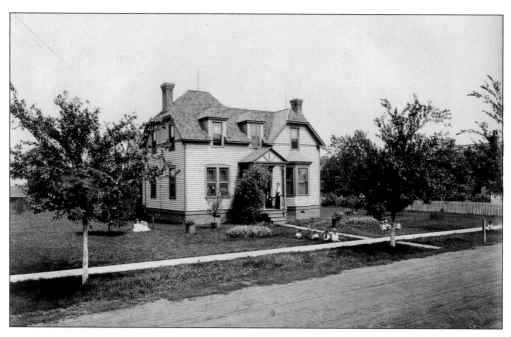

The home at 744 Holyoake Road was built in the 1890s and purchased by William H. West and his wife Amelia (Jennie) shortly after they moved to Edwardsville in 1905. Sometime before 1911, major revisions were made to the porch (below). William, an employee of the Brass Shop for 35 years, and his family would be longtime owners of the house. When he died in 1943, Jennie remained in the home, renting out the extra rooms, until her death in 1952. (Both, courtesy of MCHS.)

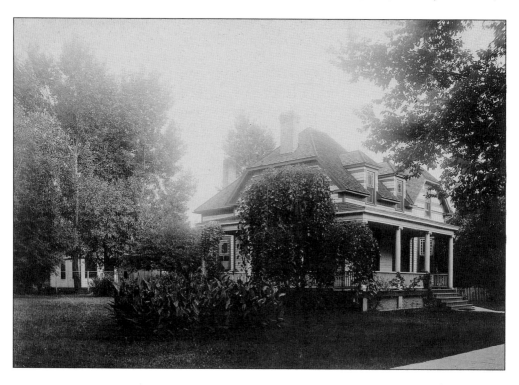

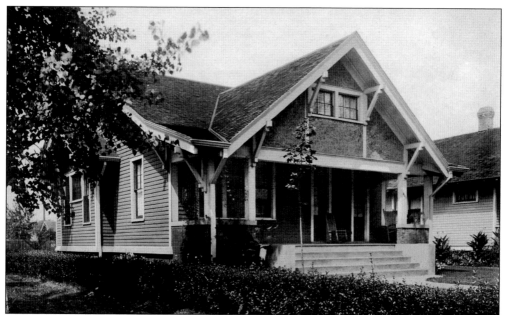

Around 1911, William Louis Sehnert and his wife, Nora, purchased this house at 837 Troy Road, where they would reside until 1947. As a young man, Sehnert worked as a laborer in the Brass Shop in Leclaire and lived nearby on Brown Street. When Leclaire was founded, Sehnert's parents built the Sehnert Hotel just outside Leclaire to take advantage of the many visitors arriving at the Clover Leaf Station. (Courtesy of MCHS.)

John Duncan, a foreman for Nelson, paid $2,588 for 904 Troy Road (right) in 1911. Three years later, Jacob Mueri, also a Nelson employee, would purchase 902 Troy Road for $2,150. Both families may have occupied the houses for some time prior to these dates. Because Nelson financed many of the house sales for employees, warranty deeds often were not filed until payment was completed. (Courtesy of MCHS.)

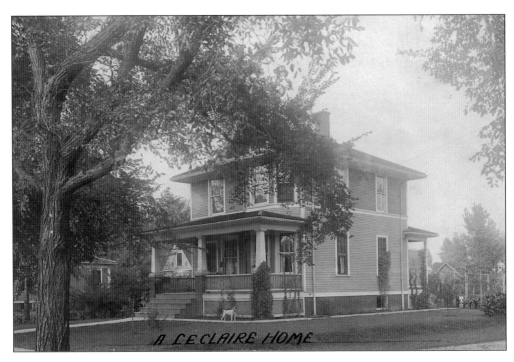

A LECLAIRE HOME

The 1934 Edwardsville city election pitted Reuben Glass of 1014 Troy Road (above) against Herbert Abbee of 1024 Troy Road in a race to become Leclaire's first alderman. At the time, their houses sat side by side. Glass was an Edwardsville native and longtime Leclaire resident who was instrumental in organizing the petition drive to annex Leclaire to Edwardsville. He was employed at the Leclaire factories. Abbee, an English immigrant, moved to Leclaire in 1916. He was an employee of the Litchfield and Madison (L&M) Railway and also participated in the annexation process. Abbee would win the close race. The Reuben Glass residence is a Sears Model Home. (Both, courtesy of MCHS.)

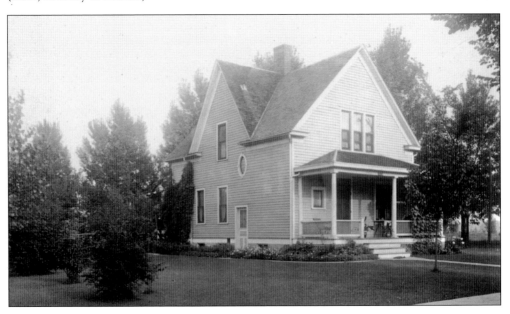

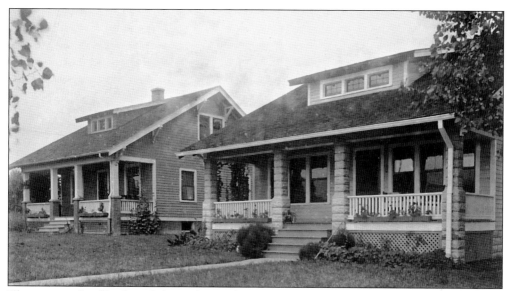

The area south of Leclaire Lake and east of Troy Road platted in 1910 was the last of Nelson's acreage to be developed. Lots were sold during a promotion in 1912 to market all the remaining unsold Leclaire parcels. One of those properties was 409 Franklin (right), a Sears house built for E. Roy Neece and family. (Courtesy of MCHS.)

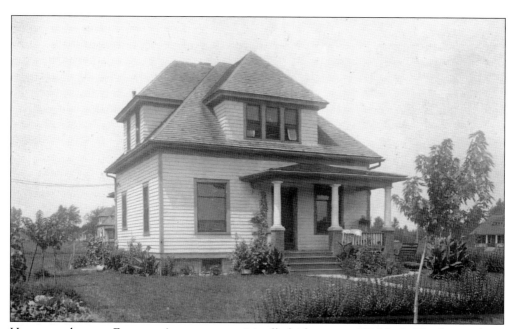

House numbers on Emerson Avenue were originally laid out as a 100 block. The house above at 1215 Emerson Avenue (originally listed as 115 Emerson) was built around 1915 for Gottlieb Buettemeier, a retired Hamel farmer. (Courtesy of MCHS.)

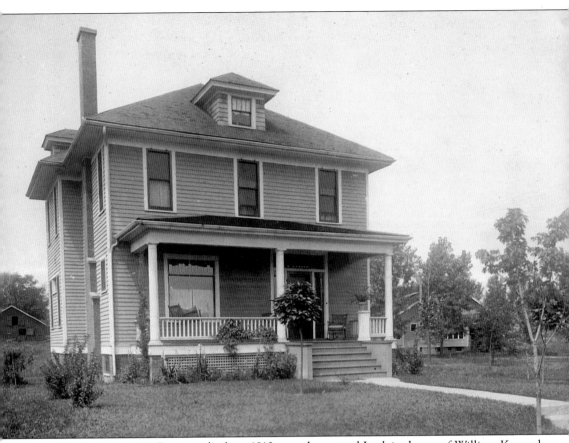

This home at 1203 Emerson, built in 1913, was the second Leclaire home of William Kennedy, who had previously lived on Holyoake Road. Seen behind the house on the left is the barn of the Leclaire farm, located just off Troy Road. Before lots were laid out, crops were planted on the undeveloped property and the produce sold at the cooperative store or taken to St. Louis to be distributed among the poor. This old barn was a preexisting structure when Nelson bought the property. It burned down in 1922 in a swift fire that destroyed all the contents, including several horses. Streetcars running down Troy Road had to be halted during the fire so the hose could be connected to the hydrant, a block away at the northwest corner of Hale Avenue and Troy Road. (Courtesy of MCHS.)

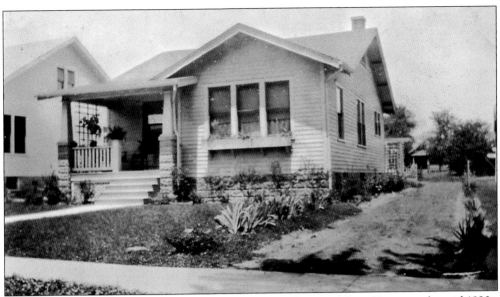

This home at 217 McKinley Avenue was built for A. Gilbert and Erna Kriege in the mid-1920s. When the Kriege family purchased the home, the address was 221 McKinley Avenue, but the houses on that street were renumbered around 1933. The Krieges' daughter Betty Lou attended the old Leclaire School on Holyoake Road. (Courtesy of Betty Kriege Fedor.)

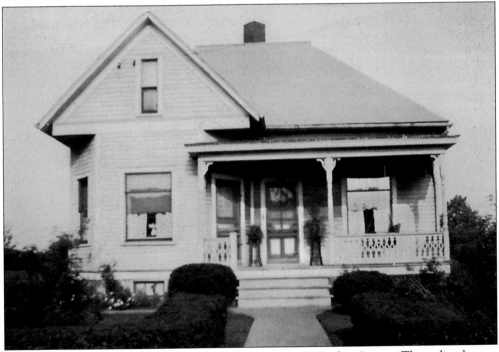

One of the first homes built in Leclaire Addition no. 1 was 829 Ruskin Avenue. The earliest known owner was coal miner John Simunek and his family in 1907. Simunek's deed for the property, filed in 1912, posted a price of $2,093 for the house. The family of Harry C. Hanser would occupy the house for many years beginning in 1925. Hanser was a city alderman when he died in 1952. (Courtesy of Dorothy Hanser Kleuter.)

The young couples who built these homes were related. The house at 216 Franklin (above) was built for Oscar and Ruby Bardelmeier when they were married in 1930. Oscar's sister Alice married Edwin Schlechte, and they built a house at 1022 Longfellow Avenue (below). Oscar and Alice grew up on a farm near Hamel, but their spouses were both Leclaire natives who would begin their married lives within a few blocks of their childhood homes. (Above, courtesy of Carol Bardelmeier Ferry; below, courtesy of Ruth Schlechte Heepke.)

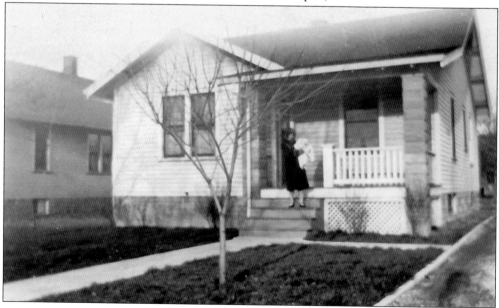

Five

THE FAMILIES OF LECLAIRE

This photograph of N. O. Nelson was on the cover of a memorial brochure sent by the company to Nelson's friends, family, and business associates. Its concluding paragraph reads, "Age never diminished his interest in national and international affairs. The years never lessened his desire to help the poor. To the very last he was a mental stimulant to his friends and a material stimulant to the suffering. He was a great man, strong and true to his visions and his convictions in spite of all obstacles and unto the very end." The family received hundreds of letters of condolence from national leaders as well as individuals to whom Nelson had offered a hand up the economic ladder. (Courtesy of Missouri History Museum, St. Louis.)

Nelson referred to himself in correspondence and written articles as N. O. Nelson. His given name was so seldom written that for many years historians remained uncertain what N. O. represented. A document in Nelson's own hand at the Missouri Historical Society gives his name as Nelson Oliver. But a family history from Norway records his name as Nels Olaus, so perhaps like many immigrants, Nelson Americanized his name. (Courtesy of Missouri History Museum, St. Louis.)

This profile portrait of N. O. Nelson was featured with a lengthy article about Leclaire published in *Arena* magazine in 1906. Leclaire and its founder were the subjects of newspaper and magazine articles in a wide variety of national publications as diverse as the *New York World*, *Technical World* magazine, *Bulletin of the Department of Labor*, *Independent Weekly*, and *The Hobo News*. (Courtesy of MCHS.)

Many of Nelson's influences are reflected in Leclaire's street names: Ralph Waldo Emerson, the Transcendentalist; George Jacob Holyoake, the "old man" of cooperation; Edward Everett Hale, reformer and Unitarian minister; John Ruskin, an advocate of Christian Socialism; Benjamin Franklin, American statesman and inventor; and Presidents Thomas Jefferson, Abraham Lincoln, William McKinley, James Monroe, and James Madison. When annexed to Edwardsville, Lincoln Avenue was changed to Nelson Avenue and Monroe to Lindenwood because Edwardsville already had streets with those names. (Courtesy of Missouri History Museum, St. Louis.)

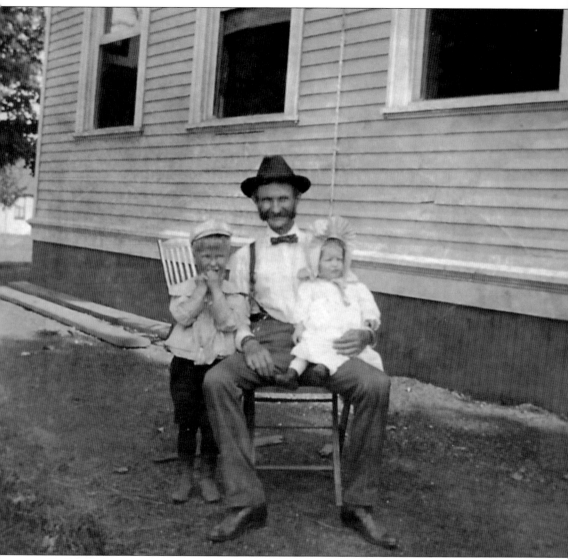

N. O. Nelson is shown with two unidentified children in 1899. Nelson was known for his love of children and often accompanied groups of Leclaire children on field trips to St. Louis or the theater. He personally sponsored the children's Horticulture Club in Leclaire. Many of his philanthropic endeavors, like the Fresh Air Missions, benefited underprivileged youth. (Courtesy of MCHS.)

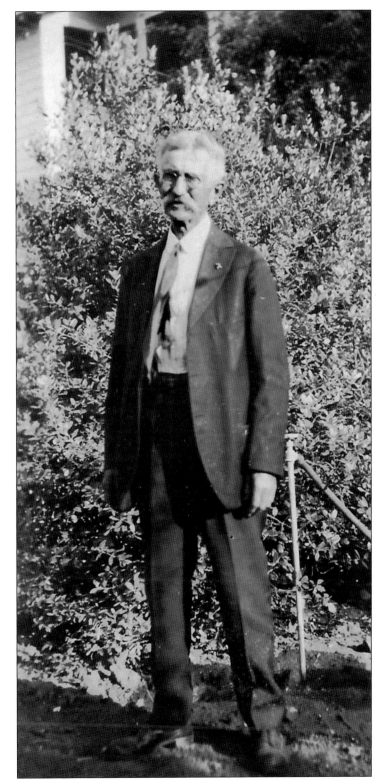

In 1917, N. O. Nelson, at the age of 71, tried unsuccessfully to enlist for service in World War I. Since the Civil War veteran could not enlist himself, he sent out a notice to the company's 500 employees across the country saying he would pay their difference in income if they enlisted and would support the dependents of "those who fill a hero's grave." After the war, in a company report to the government, Nelson listed 31 Leclaire workers who enlisted. Of those men, 17 returned to work at Leclaire, and four died while in service. (Courtesy of MCHS.)

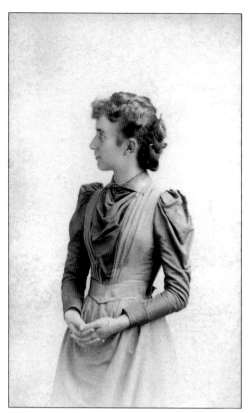

These portraits of Nelson's daughters make
it clear that although their father enjoyed
the simple life in Leclaire, his family was
accustomed to the less austere lifestyle of a
wealthy businessman. Julia Nelson, pictured at
left in 1890, married Louis D. Lawnin, a long-
time Nelson employee who became president
of the company in 1918 when his father-
in-law retired. Pictured below is Charlotte
Nelson, who married Edward Burroughs,
an Edwardsville dentist from a prominent
family. Dr. and Mrs. Burroughs, and later
their daughter Winifred and her husband
William Southwick, lived in Nelson's former
Leclaire home. (Left courtesy of Mary Moseley
Armstrong; below courtesy of MCHS.)

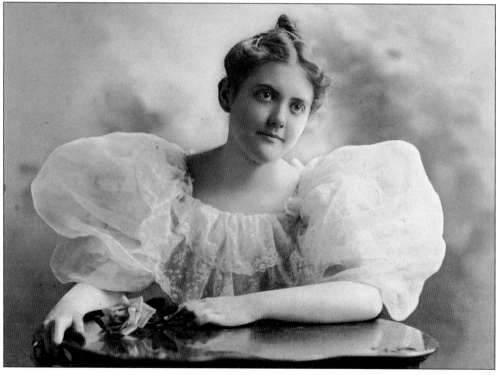

Almeria Nelson, pictured here with her granddaughter, Winifred, was supportive of her husband's activities for the betterment of society. She founded several social clubs in Leclaire and Edwardsville and volunteered for the American Red Cross during World War I. (Courtesy of MCHS.)

Shown here at work in his garden at Indio, California, N. O. Nelson grew up on a farm and never lost his love of working with the earth. In 1906, he wrote about his pleasure in rising early, and, after a cup of coffee, stepping out to the garden to work with his flowers before beginning the day. He described his tulip beds as "bright enough to light up the night." (Courtesy of MCHS.)

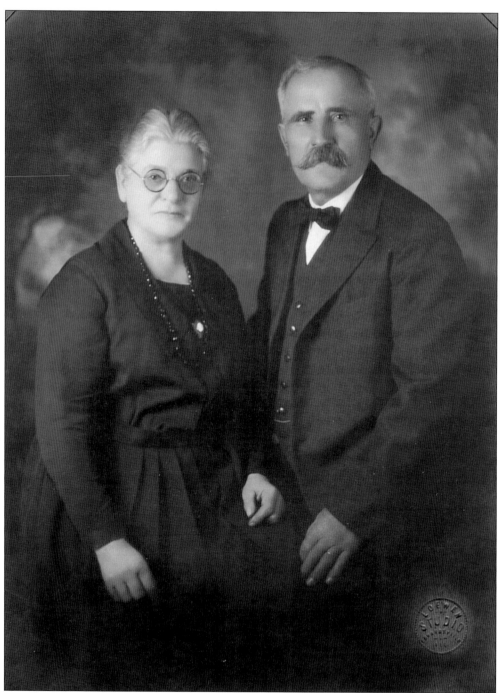

Giuseppe (Joseph) Rizzoli, his wife, Clementina, and their children were some of the earliest Leclaire residents. In 1894, reporter Nellie Bly came to Leclaire to do research for an article in the *New York World* in which she told the story of an Italian workman, a "fine cabinetmaker," who earned $2.50 per day and paid $18 per month to buy "one of the prettiest houses in Leclaire." Bly was referring to the Rizzoli family, whose home at 854 Hale Avenue was pictured in the article. (Courtesy of Christine Taul.)

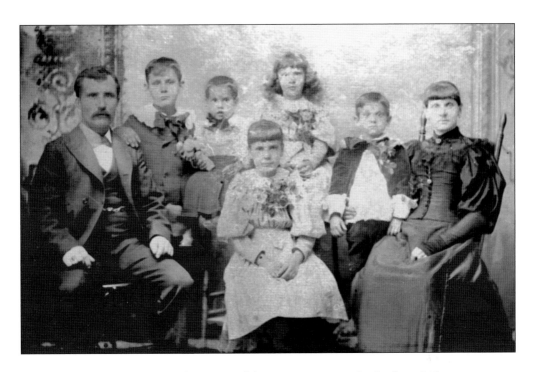

The Rizzolis are representative of a pattern of clan migration typical in Leclaire. Italian immigrants from Tyrol, they were followed to Leclaire by two of Clementina Rizzoli's brothers (Erspamers). The Joseph Rizzoli family is pictured here around 1891 (above) and 1895 (below). The parents, Joseph and Clementina, raised their family at 854 Hale Avenue. Three of their children resided nearby. Emma and her husband, Erwin, lived down the block at 716 Hale Avenue; Joseph Jr. built a house right behind his parents at 513 Jefferson Road; and Daliso built a home at 1024 Longfellow Avenue in 1923. Although most of the Rizzoli men worked for Nelson at some time in their careers, none was a longtime employee. Joseph would be one of the founders of the Edwardsville Planing Mill, where several of his sons would also find work. (Both, courtesy of Robert Hyten.)

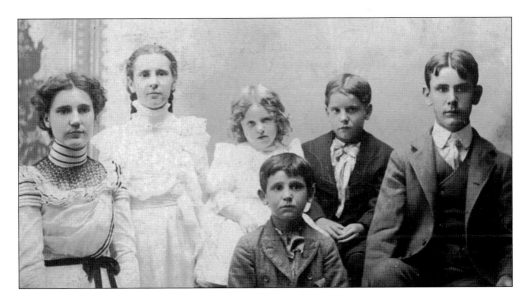

Young Helen Rizzoli was the daughter of Daliso and Essa Rizzoli. Helen's mother died less than a year after she was born, so she stayed with her aunt, Emma Sehnert, for several years until her father remarried and could reunite his family. Helen became a nurse, serving in World War II and, at the end of her career, at Southern Illinois University Edwardsville. (Courtesy of Christine Taul.)

This sweet portrait of mother and child shows Emma Rizzoli Sehnert and her son Erwin (Frank) Sehnert Jr. Tragically, Frank, Emma's only child, was killed at the age of 28. In the days when vehicles needed to be cranked to start, he mistakenly left his vehicle out of gear. When he cranked the truck it lurched forward, pinning him between it and another truck, causing fatal internal injuries. (Courtesy of Robert Hyten.)

Ciro Erspamer began working for N. O. Nelson Manufacturing in 1892. He worked in the Cabinet Mill and lived in Leclaire in those early years. In 1895, he went home to Tyrol to visit his mother and perhaps met his future wife at that time. Three years later, he returned home to marry, but while there had the misfortune to be drafted into the Austrian army. After two years service, he returned to Edwardsville, where he made a successful business as a builder and contractor. (Courtesy of Robert Hyten.)

The Kuethe family lived at 905 Hale Avenue in the 1920s and early 1930s. Pictured above are, from left to right, Anna (Mrs. Fred) Keuthe, Helen, Elsie, and Raymond Kuethe. Below is Fred Kuethe at the back of the house. In the early 1930s, 905 Hale was purchased by the Coroniotis family, which ran a wholesale meat business from that location. The house is across the street from Leclaire Park. (Both, courtesy of Roger Buchta.)

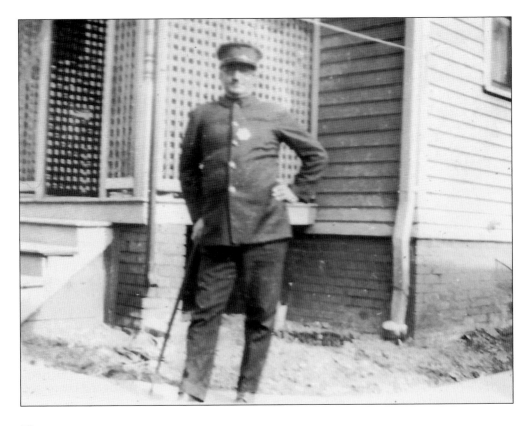

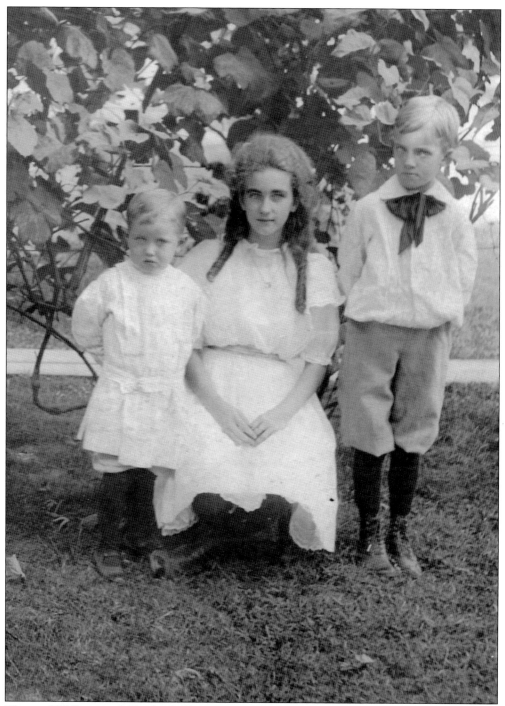

Three of William and Elizabeth Shaw's seven children are pictured here around 1910. Evan (left) would live in Leclaire his entire life. He built a home at 501 Franklin in Leclaire. Mildred (center) taught school while living at the family home at 409 Jefferson Road until her marriage to Edwin Briggs in 1943. Kenneth Shaw left Leclaire for a home on Abner Place in Edwardsville. (Courtesy of Elizabeth Shaw Stolte.)

Beginning in 1922, the Henry Meikamp family lived at 310 Jefferson Road for 12 years when Henry worked for the N. O. Nelson Manufacturing Company as a fireman in the boiler room. The Meikamps had three children—Irene, Harold, and Virgil. Irene (left) and Virgil (below) are pictured here. Virgil suffered from juvenile diabetes at a time when treatment was not as effective as today. He passed away in 1934 at the age of 11 after what the newspaper called "nine years of illness." (Both, courtesy of Helen Meikamp.)

Matt Fagan Jr. grew up on Sherman Avenue just outside Leclaire. His father and grandfather both worked for Nelson. A series of pictures taken of the young boy in 1927 also preserve images of numerous sites in Leclaire. The photograph at right shows him at the Nelson Memorial Fountain. The photograph below was taken in Leclaire Park and is the only early picture discovered of 935 Hale Avenue. (Both, courtesy of MCHS.)

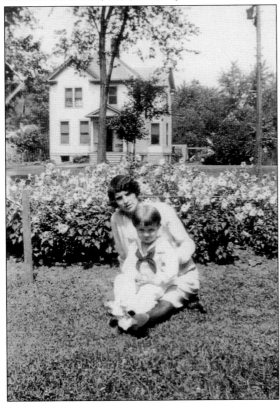

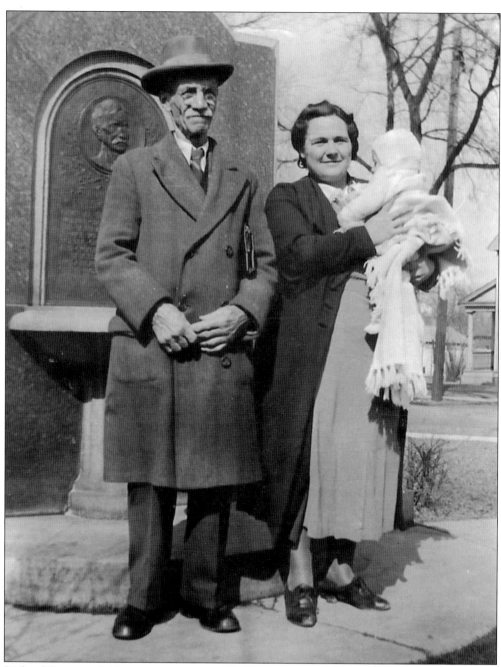

Richard Fagan, an Irish immigrant, came to St. Louis in 1889 and went to work for N. O. Nelson. When the Brass Shop moved to Leclaire, Fagan transferred with it, living first on Dewey Avenue and later at 423 Plum Street in The Orchards. A number of Leclaire workers lived in the Orchards subdivision, since it was only a few blocks from the shops in Leclaire. Fagan's sons Matthew and Jerrett also worked for Nelson for a time. Matthew apprenticed as a machinist and later worked as a polisher, and Jerrett worked in the Brass Shop. Richard (left) is standing in front of the Nelson Memorial Fountain with his daughter-in-law Marie and grandson Terry. (Courtesy of Mary Ann Alderson.)

Shirley and Dorothy Nix are shown standing on the back porch of their home on the southeast corner of Franklin Avenue and Troy Road around 1934. They were the youngest of ten children born to Oliver and Gertrude Nix. Oliver was a skilled carpenter in Nelson's Cabinet Mill. His brother, William Nix, lived on Hale Avenue and was a machinist in the Machine Shop. (Courtesy of Gary Gerhard.)

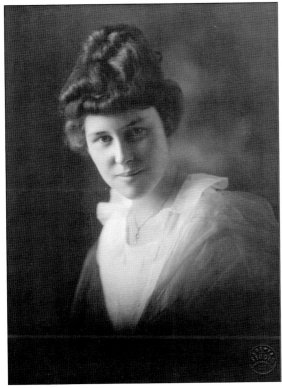

Mabel Allen lived in her childhood home at 926 Holyoake Road nearly all her life. She was 55 years old when she married widower George Moorman Sr. Mabel had been his secretary in the Nelson Company office for many years and lived across the street from the Moorman family. The new Mr. and Mrs. Moorman made their home in the Allen house. (Courtesy of Carol Ferry.)

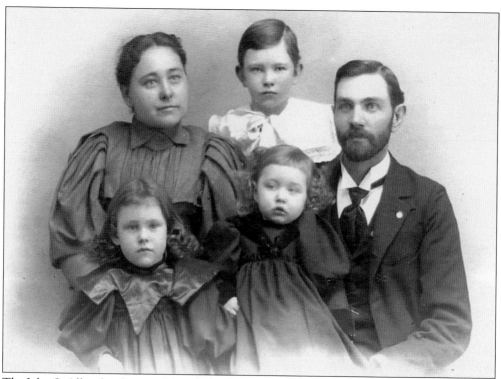

The John S. Allen family poses (above) shortly before moving to Leclaire in 1907. They are, from left to right, (first row) Mabel, Glen, and John; (second row) Mary Alice and Stewart. John Allen was a foreman in the packing room. Around 1930, the Allen family stands in front of the home at 926 Holyoake Road (below). From left to right are (first row) Lula (Mrs. Glenn), John S., Alice, and Ruby; (second row) Jim, Mabel, and Glenn. (Both, courtesy of Carol Ferry.)

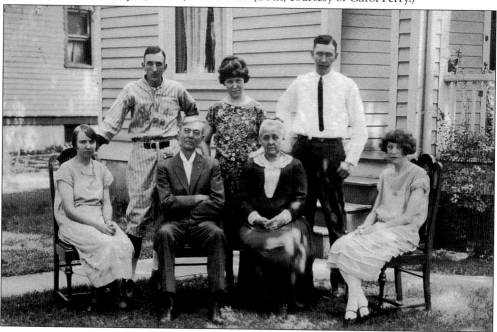

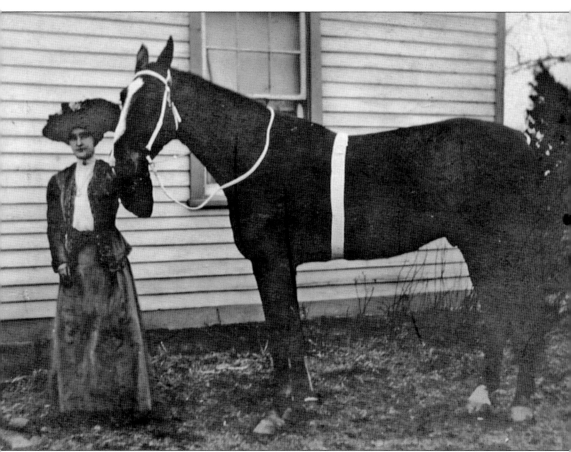

Isabel Yates poses in 1909 with her racehorse Jim Majestic for this picture postcard. Two years later, in January 1911, she was murdered by her husband, George, at their home on Holyoake Road. In the commission of the crime, she was shot twice and her throat slit. George Yates, who calmly walked to town to turn himself in after the murder, was sentenced to 45 years at the Menard State Prison. Following the crime, his family could not sell the property. It was made available as a rental, but renters soon moved out, complaining of spirits in the house. The solution was to sell the house to Yates's sister and her husband, Mr. and Mrs. Russell Kinder. The Kinders lived in the house long enough for the stigma of the crime to abate; they sold it in 1922. Thereafter, the new owners regularly advertised "furnished rooms with light housekeeping" until the 1940s, when it once again became a single family home. (Courtesy of Joan Evers.)

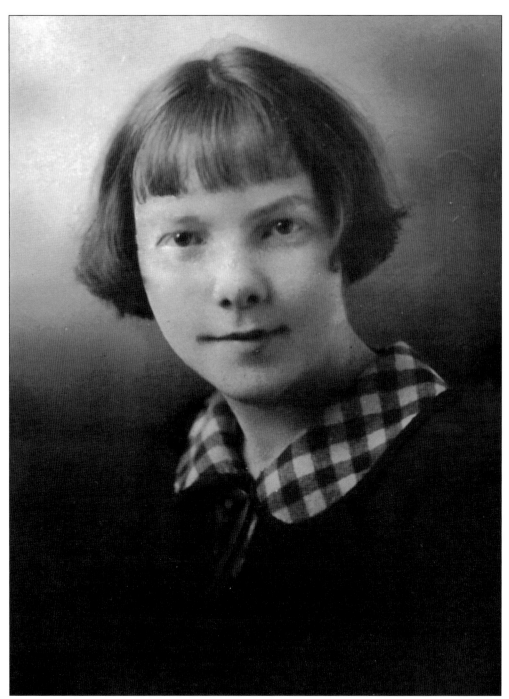

Cleopatra (Cleo) Kinder, along with her parents, moved into the house at 922 Holyoake Road a few years after the Yates murder occurred there. Unlike others who occupied the house immediately after the murder, the Kinders had no supernatural experiences. Cleo spoke fondly of her years in Leclaire, where she would get up on summer mornings and whistle to friends as an invitation to join her down at the lake for a swim. This is Cleo's senior portrait taken in 1924, two years after the family moved from Leclaire. (Courtesy of Joan Evers.)

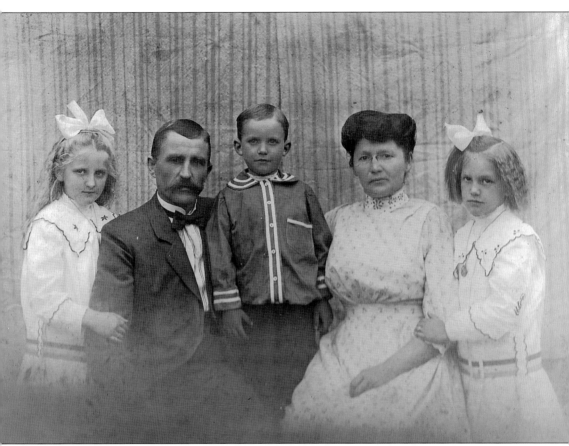

John and Katherine Staaf and children Carol, Arnold, and Clara are pictured here around 1916. The parents were both German immigrants, with John (formerly Johannes) obtaining citizenship through naturalization in 1915. This industrious family had income from several sources. John was a coal miner and his wife ran a dairy business out of the house, with the assistance of their three children. Milk was obtained from a Glen Carbon farmer and then brought to the house for processing and bottling. Daily deliveries were made to her customers. There was a long garage on the side of the house where some of the work was done, and the home had a walk-in cooler in the basement. (Courtesy of Roger Buchta.)

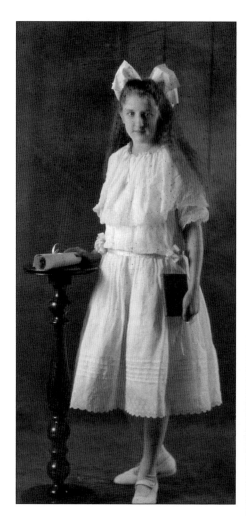

The Staaf family attended Eden United Church of Christ, where the children were confirmed. The c. 1920 photograph at left shows Carol's confirmation. Her younger brother Arnold, pictured below around 1924, would later marry Elsie Kuethe, who lived on Hale Avenue. The three Staaf children and the Kuethe sisters were good friends who took hundreds of photographs in the Leclaire/Edwardsville area during the 1920s. (Both, courtesy of Roger Buchta.)

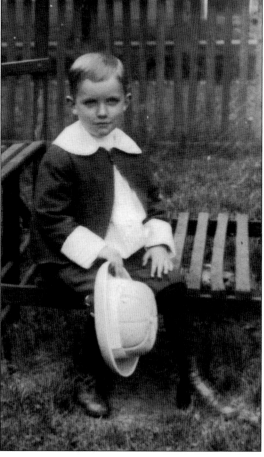

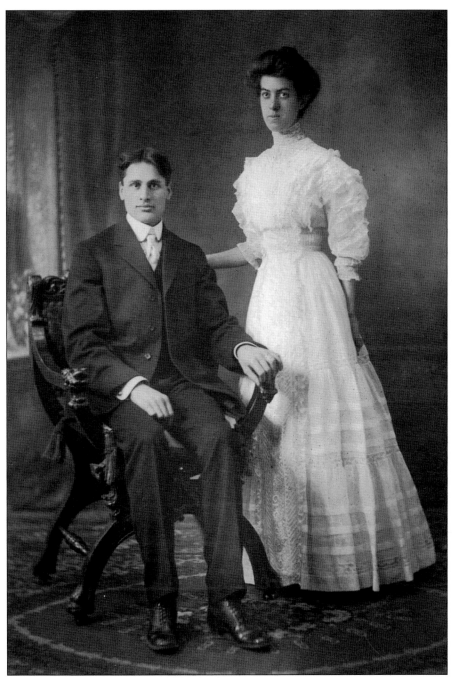

George and May (nee McCune) Moorman were married on June 30, 1908. They lived at 303 Holyoake Road (later 929 Holyoake) where May had a china kiln in the basement. A news article in 1915 reported that she had just completed an order of two dozen globes for gaslights for the "gas and electric company." She painted and fired inscriptions like *Intelligencer* or Laundry on the globes to direct customers to the business. She was reported to be the first in Edwardsville to own a china kiln and took first place honors as a ceramist at the Madison County Centennial. (Courtesy of Betty Lipe.)

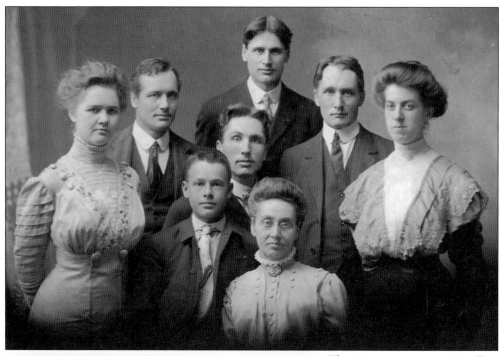

The Moormans were originally from Michigan, where May Alger married Enos Moorman in 1876. Five sons survived infancy and are pictured above around 1908 with their mother, seated in front. Other family members pictured are, from left to right, Naomi (Frank's wife), Edwin Alberto (Bert), Clair, Ivan, George, Frank, and May (George's wife). In the mid-1890s, eldest son Frank moved to Edwardsville and found work with N. O. Nelson Manufacturing. When Enos left the family, May eventually moved to Illinois with the rest of her boys to be near Frank. The family became community leaders in both Leclaire and Edwardsville. In the 1909 image at left are Mary McCune and her granddaughter Elizabeth Moorman, George and May's eldest. (Both, courtesy of Betty Lipe.)

In the *c.* 1917 image at right, Isabelle Gilmor (right) poses with an unidentified friend. She and her brother Marcus, pictured below around 1914, were the youngest children of Joseph and Adelia Gilmor, who lived at 917 Holyoake Road in the west side of Leclaire's only duplex. (Both, courtesy of Ed Kane.)

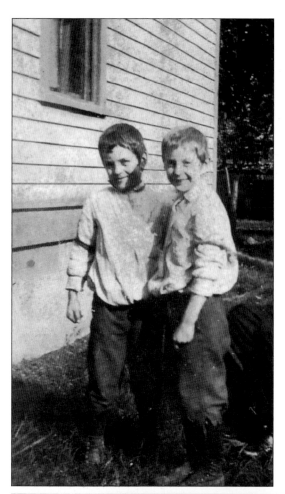

John F. Reid and his wife Monetta (Nettie) moved to the house at 848 Holyoake Road (below) shortly after their 1901 marriage and called it home until their deaths in the mid-1950s. Although John Reid worked for Nelson only a short time before going to work at a local coal mine, the couple evidently had a great admiration for N. O. Nelson and company superintendent Louis D. Lawnin. The twin boys shown at left, born in 1907, were named Nelson and Lawnin Reid. (Both, courtesy of Richard Reid.)

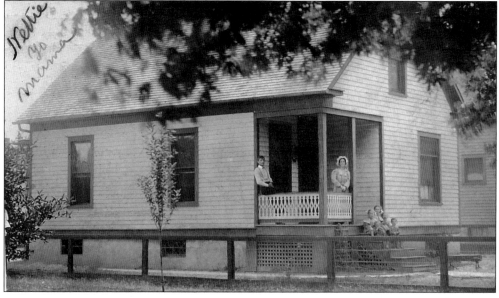

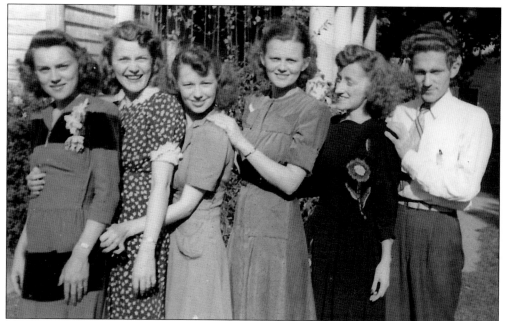

The Rotter family was one of the earliest in Leclaire. Pius Rotter Sr., a cabinetmaker for Nelson, raised his family at 811 Holyoake Road. Pius Rotter Jr., a Nelson machinist, married Mary Catherine Foehrkolb in 1911, and they made their home just outside Leclaire on Sherman Avenue. Mary died in 1920, leaving Pius with six children, all under the age of nine. By 1930, he had moved with his children to his parent's home at 811 Holyoake. Pictured above are the children of Pius Rotter Jr. They are, from left to right, Edna, Agnes, Elsie, Marie, Frances, and Joseph. Some of the Rotter sisters are included in the c. 1922 group photograph below. They are, from left to right, (first row) Agnes, Marie, Ed Klostermeier, and Dorothy Klosterman; (second row) Mary Klosterman, Elsie, and Frances. (Above, courtesy of Judy Veith; below, courtesy of Joseph Rotter Jr.)

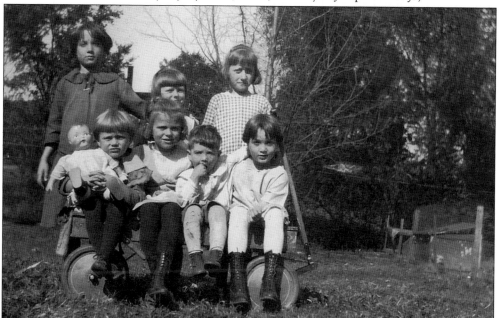

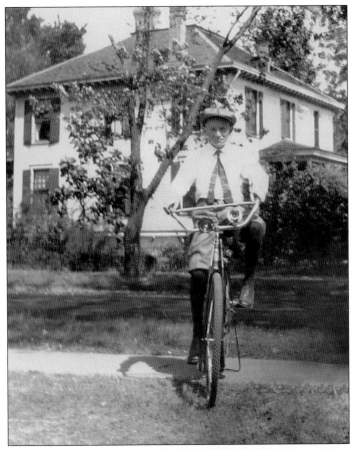

Joseph Rotter poses on his bicycle in his family's front yard around 1925 (left). The home of Leclaire founder N. O. Nelson can be seen behind him. Below, two unknown neighborhood boys pose on a bicycle in front of one of the Nelson factory buildings. The make and model of the bicycles shown here are unknown, but for two years in the mid-1890s, Nelson produced Leclaire brand bicycles through its Bignall and Keeler division. In 1896, the company also announced that its bicycles could be rented. (Both, courtesy of Joseph Rotter Jr.)

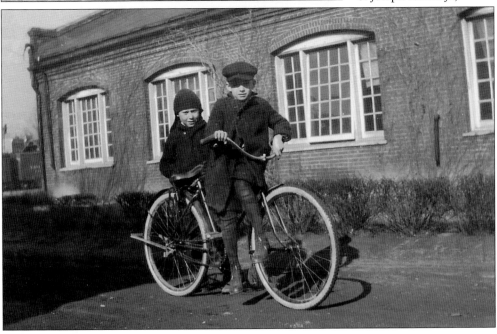

Betty Lou Kriege (right) celebrates her third birthday with Betty Lu Schiermeyer and the family dog at 221 (later 217) McKinley Avenue in this image from 1931. Betty's parents built the house in the mid-1920s and lived there until 1940. (Courtesy of Betty Lou Kriege Fedor.)

Greek immigrant Costa C. Coroniotis and his wife Magdalena lived at two different Leclaire addresses before buying a house at 905 Hale Avenue. Coroniotis ran a corner grocery on Route 66 prior to moving to Leclaire, where he started a wholesale meat business. Coroniotis was a World War I veteran and was very active in community organizations. The c. 1933 pictures on this page show his daughter, Helen, in front of the family home at 822 Ruskin Avenue. In the photograph at left, the lucky girl has two Easter baskets; below, she is modeling her mother's fox stole. (Both, courtesy of Helen Coroniotis Wiemers.)

This Longfellow Avenue gang makes a charming backyard quartet in 1932. The group includes, from left to right, Geraldine Schwager, Ruth Schlechte, and Charles and Joseph Rizzoli. Geraldine (Gerry) is the daughter of A. Fred and Julia Schwager, who lived at 205 McKinley Avenue. Ruth is the daughter of Edwin and Alice Schlechte, of 1022 Longfellow Avenue; and brothers Charles and Joseph, sons of Daliso and Oda Rizzoli, lived at 1024 Longfellow Avenue. (Courtesy of Christine Taul and Ruth Schlechte Heepke.)

Three smiling boys—Joseph and Charles Rizzoli and friend Richard Van Hook—are pictured here around 1930. No one knew on this innocent day that Charles, Joseph's protective older brother, would be killed in action less than 14 years later in World War II's Battle of the Bulge. (Courtesy of Christine Taul.)

The bride and groom and their fathers in September 1929 (above) were all Leclaire residents. Edward Bardelmeier (above left) was a farmer who retired to a house at 212 Franklin Avenue. August Schlechte (above right), a machinist at N. O. Nelson Manufacturing, purchased a home at 1021 Ruskin in 1910. His son Edwin (groom) worked as a blacksmith for Nelson's Bignall and Keeler Division. Just before his marriage to Alice Bardelmeier, he hired Theuer Contractors to build a house at 1022 Longfellow Avenue. Edwin poses in his backyard with daughter Ruth around 1934 (right). Edwin had a small greenhouse and enjoyed tending his roses. (Both, courtesy of Ruth Schlechte Heepke.)

Edward and Addy Bardelmeier and children Alice and Oscar are shown in this portrait taken in the mid-1920s. As indicated earlier, Alice and her parents would come to live in Leclaire. In 1930, Oscar married Ruby Allen, who grew up at 926 Holyoake Road. He would also become a Leclaire resident when he bought a new house for his bride at 216 Franklin Avenue. (Courtesy of Ruth Schlechte Heepke.)

After Arno and Minnie Schlechte's 1920 wedding in St. Louis, they made their residence at 1012 Ruskin, near Arno's childhood home. Arno, a machinist for Nelson's Bignall and Keeler Division for 33 years, had two hobbies noted in early newspapers. He grew hundreds of irises on a lot on Longfellow Avenue, and he created a miniature circus that he displayed at hobby shows and community gatherings. Pictured from left to right are Edwin Schlechte, Lydia Clausen, Minnie Clausen Schlechte, and Arno Schlechte. (Courtesy of Ruth Schlechte Heepke.)

Belva (left) and Dolores Howerton grew up at 1014 Ruskin Avenue. Their parents, Sam and Ida Howerton, purchased the Ruskin Avenue house for $1,900 shortly after their November 12, 1918, marriage. Both girls attended the Leclaire Kindergarten. (Courtesy of Dolores Howerton Rohrkaste.)

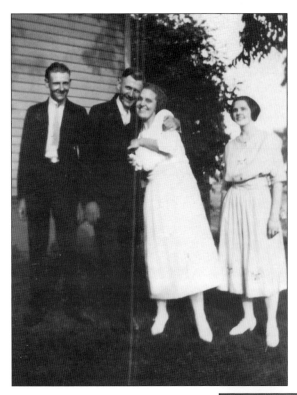

In 1922, Harry C. Hanser and Bernadine Huntsman (left) were married at his family's home on the north side of Edwardsville. They began married life at 829 Ruskin Avenue in Leclaire, where they would raise three children—Norma (below left), Dorothy (below right) and a son, Carl (not pictured). When the Hansers lived on Ruskin Avenue, trains on the west side of Longfellow Avenue were a common sight. Many homes in Leclaire were marked by hoboes riding the rails so they would know where they might get a bite to eat. (Both, courtesy of Dorothy Hanser Kleuter)

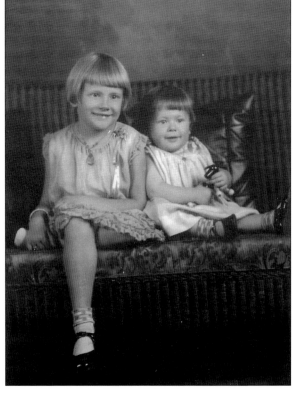

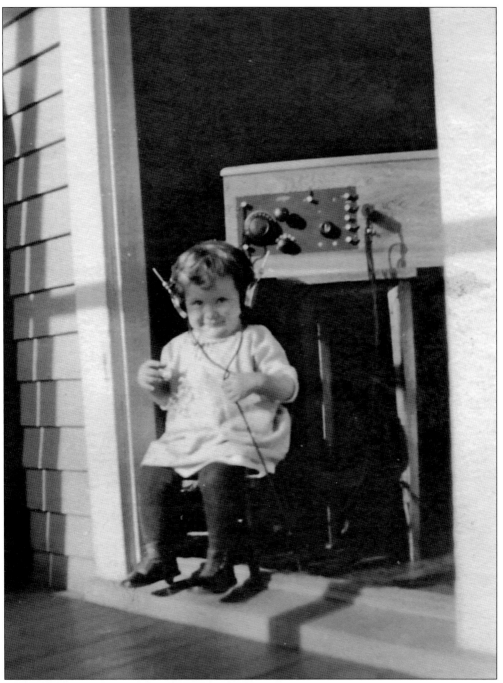

Listening to the radio through headphones, Norma Hanser sits in the doorway of her home at 829 Ruskin Avenue around 1926. (Courtesy of Dorothy Hanser Kleuter.)

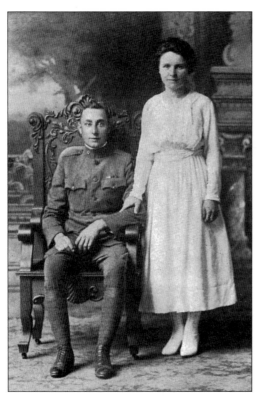

During World War I, Edward Volz (left) served nine months in the army and then came home to marry his sweetheart, Lillian Dauderman (right), of Alhambra, in June 1919. Soon after, the young couple purchased a house at 824 Troy Road in Leclaire, across the street from Edward's brother Joseph. Edward would find employment with Nelson initially, but later worked for the power company. (Courtesy of Evelyn Volz Lane.)

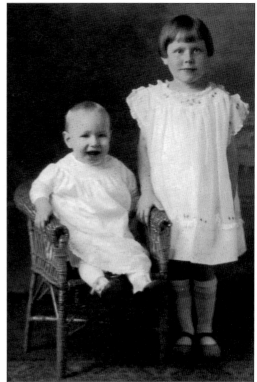

The Volzes had three children. In 1925, the eldest, Evelyn (right) and Wilbur, posed for this photograph. (Courtesy of Evelyn Volz Lane.)

Wilbur Volz is shown in the backyard of 824 Troy Road (right). The grape arbor seen here was typical of Leclaire, where many families made their own wine or jam. In front of the same house around 1925 are Dorothy Waltering and Evelyn Volz (below). In the background is the Joseph Volz home at 821 Troy Road. Joseph was Evelyn's uncle. (Both, courtesy of Evelyn Volz Lane.)

Loretta Pizzini is shown in the backyard of her home at 1104 Troy Road as she prepares to water the family garden around 1926. Loretta was the daughter of William and Florence Pizzini. She attended Leclaire Kindergarten, riding her tricycle to school and back with her friend Lola Mae Hopcroft, who lived around the corner on Franklin Avenue. Loretta graduated from the free kindergarten in 1929. (Courtesy of Loretta Stullken.)

Six

LIFE IN THE VILLAGE

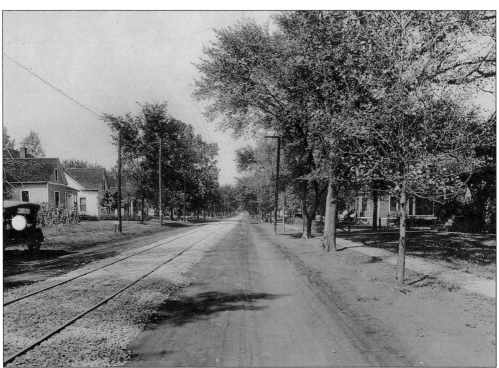

On September 3, 1901, the first electric streetcar arrived in Edwardsville. The occasion was celebrated with a blast of factory whistles in Leclaire and at the Madison Mine. The East St. Louis and Suburban streetcar system ran down the center of Troy Road in Leclaire until 1928, when automobiles became the preferred method of travel. In this photograph looking north from the corner of Troy Road and Hale Avenue, the tracks have gravel beneath them, but the street was what the *Edwardsville Intelligencer* called "the mud road par excellence." The trains were replaced with the Blue Goose, an hourly bus service. (Courtesy of St. Clair County Historical Society.)

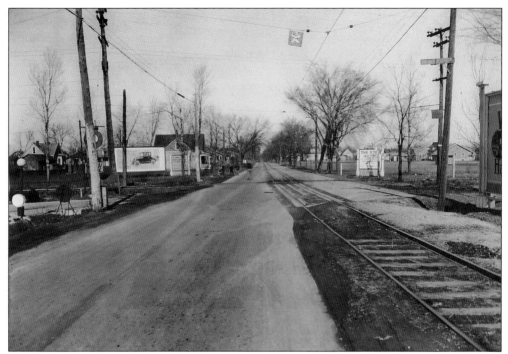

The view above is looking north from a location near where Montclaire Shopping Center is currently located. Troy Road was on the west side of the tracks up to this juncture; it then jogged to the right, so the tracks ran down the center of the road. Below is a view of the tracks looking south from a location on Troy Road in front of the present-day Market Basket. With the streetcar as well as freight trains running through Leclaire, the sight and sounds of trains was an ordinary and frequent occurrence. (Both, courtesy of St. Clair County Historical Society)

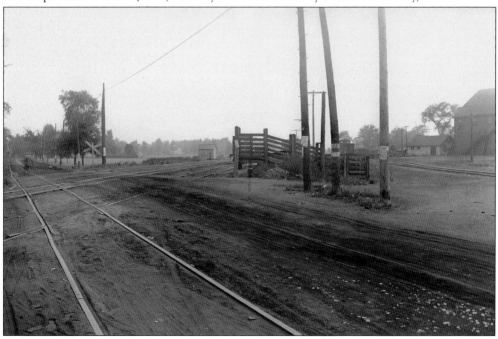

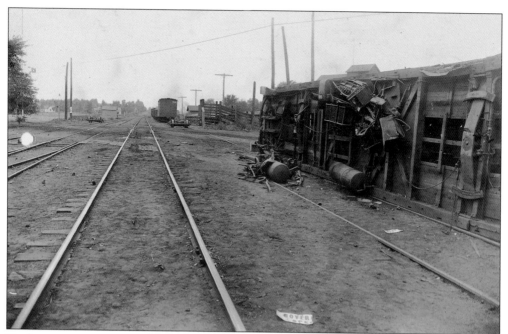

Twelve passengers were on this East St. Louis and Suburban streetcar at the Clover Leaf railroad crossing when it was struck by a freight train on August 6, 1919. Witnesses rushed to the nearest telephones to call all the doctors in town because they were certain there would be serious injuries or fatalities. Miraculously there were no life-threatening injuries, even though a woman was thrown from the streetcar and landed under a moving freight car. Her clothing was shredded, and she suffered minor cuts and bruises, but she was able to return home that evening. These photographs show the overturned streetcar. (Both, courtesy of St. Clair County Historical Society.)

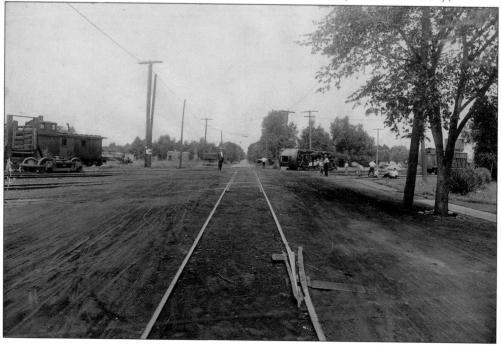

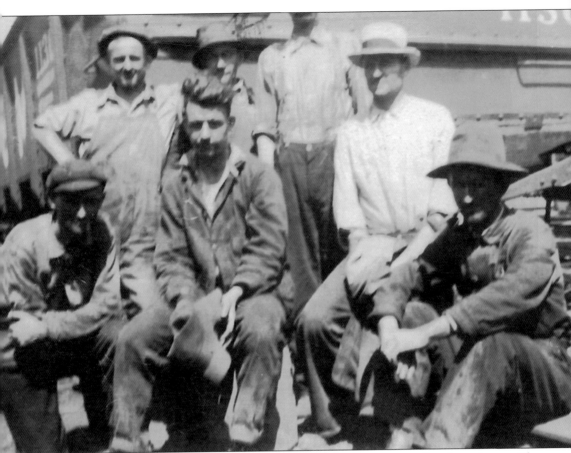

Due to the proximity of the railroads, many Leclaire residents were railroad employees. The Illinois Terminal System's Leclaire Yards adjoined the southwestern corner of Leclaire, west of Bryant Avenue. The Litchfield and Madison (L&M) and the Toledo, St. Louis and Western (later the Nickel Plate) rail lines bordered Leclaire to the west, and the Illinois Terminal's beltline circled to the east, going through Leclaire south of Franklin Avenue. The Nickel Plate Depot (formerly the Clover Leaf) was next to the Leclaire factories. Identified in this photograph of L&M workers are Russell Kinder (second row, center) and Ben Foehrkolb (first row, far right). (Courtesy of Joan Evers.)

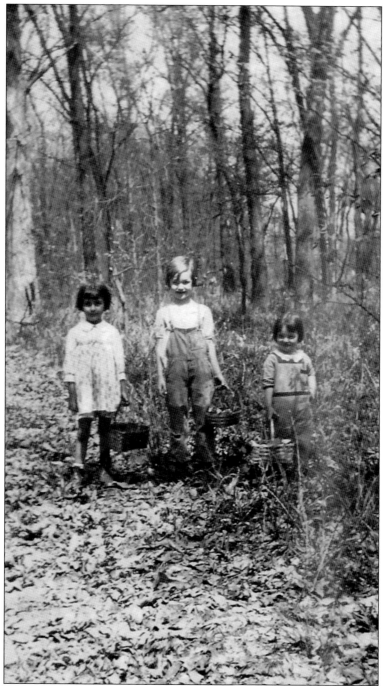

On the west side of the L&M rail lines was a wooded tract of land where local children liked to play. Most were told to avoid the hobo camp located in the woods. One resident who disobeyed her mother and visited the camp with her brother remembers it was located along a stream and had a neat fire circle. A mirror was attached to a tree for shaving and grooming. Betty Schiermeyer (left), Jane Starkey (center), and Betty Kriege are apparently in the woods to collect berries or nuts, since they are carrying baskets in this c. 1930 photograph. (Courtesy of Betty Kriege Fedor.)

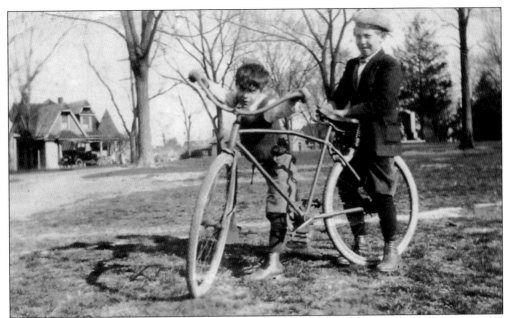

After Leclaire was founded, other neighborhoods were developed between Leclaire and Edwardsville and to the east of the factory complex. Residents of these neighborhoods were free to use the Leclaire campus athletic fields and Leclaire Lake and Park. These unidentified boys are shown on the Leclaire campus. The Sehnert home at 716 Hale Avenue is in the background. (Courtesy of Judith Veith.)

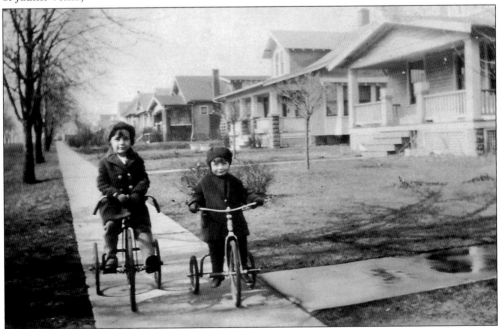

McKinley Avenue on the southwest corner of Leclaire was part of Addition no. 2, platted in 1905. With the newer additions to Leclaire, many lots were purchased as investments that were improved and sold a few years later. Most of the McKinley Avenue homes were built in the 1920s. This c. 1930 street view shows Lois and Betty Kriege on McKinley Avenue. (Courtesy of Betty Kriege Fedor.)

The streets of the original plat of Leclaire, laid out by Julius Pitzman, were designed to give the village a parklike appearance. The wide, tree-lined curvilinear thoroughfares were often photographed and reproduced on postcards. The above view is looking south on Holyoake Road from in front of the School House. The photograph below was taken from the corner of Jefferson Road and Hale Avenue, looking north. The house at the left is the home of William Shaw at 409 Jefferson Avenue. (Above, courtesy of MCHS; below, courtesy of Elizabeth Shaw Stolte.)

These street scenes of Leclaire are from a series of photographs documenting an ice storm on January 8, 1913. The above image was taken from the intersection of Hale Avenue and Holyoake Road. The two streets met on the north side of the schoolhouse until 1962 when Holyoake Road from Park Place to Hale Avenue was vacated to allow more space for a Little League baseball field. At left is a view of Holyoake Road looking south from in front of the school house. (Both, courtesy of MCHS.)

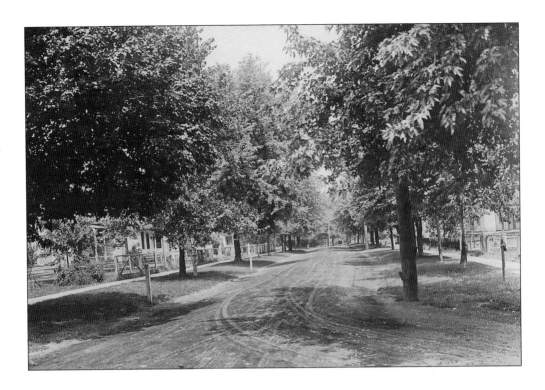

The image above is an unidentified Leclaire street scene. Hitching posts are still evident along the street, and there is a NONCO fire hydrant on the left. Below is a view of Troy Road from its intersection with Hale Avenue. The houses on the right are at 930 and 926 Holyoake Road. (Both, courtesy of MCHS.)

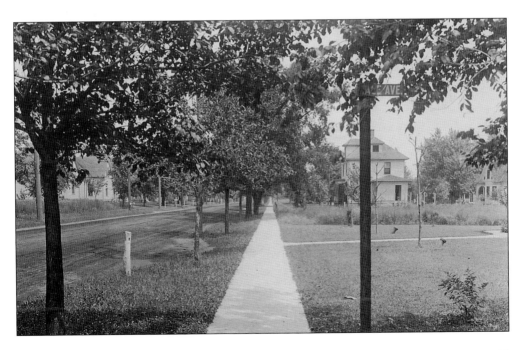

Although Leclaire had a cooperative store for groceries, residents patronized Edwardsville shops and businesses for other needs and participated in Edwardsville activities and celebrations. The Leclaire Kindergarten (above) rides on a float in celebration of the dedication of the new Madison County Courthouse on October 18, 1915. Louis D. Lawnin is on horseback; the man in front is unidentified. Below is Leclaire's parade entry at the centennial celebration of Madison County on September 16, 1912. The Japanese Pagoda driven by Louis D. Lawnin won second place. (Above courtesy of Luther Biggs; below, courtesy of MCHS.)

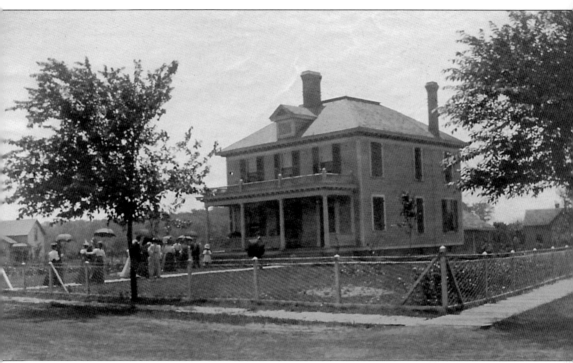

In 1899, the Bellamy Club of St. Louis made two summer excursions to Leclaire. On one of those trips, a guest, Frank Braznell, recorded the day's activities with his camera. He later sent N. O. Nelson a delightful album of photographs from the day in Leclaire. The album was donated to the Madison County Historical Museum by the Nelson family. In this image, visitors arrive at the N. O. Nelson home for their day in Leclaire. (Courtesy of MCHS.)

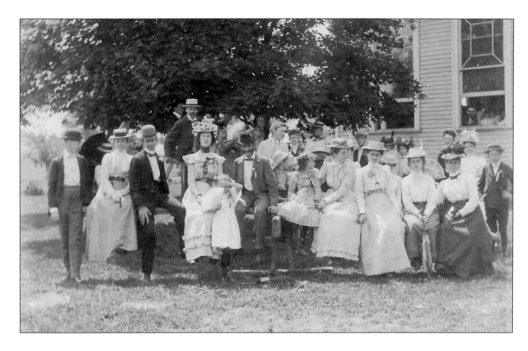

These group portraits were taken during an 1899 country visit to Leclaire. The only identified person in the photographs is N. O. Nelson (first row, center above; second row, center below). Everyone is in formal attire including jackets in the above portrait taken beside the schoolhouse. The picture below was obviously taken later in the day. Many of the gentlemen have removed their jackets, and a few of the ladies have even shed their hats. All are looking more relaxed. (Both, courtesy of MCHS.)

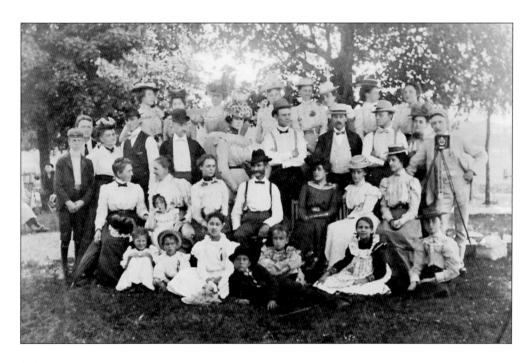

Visitors to Leclaire did not have to go far to reach open land in 1899. When this photograph was taken, the west side of Troy Road was still undeveloped, and everything south of Leclaire Lake was farmland. In this beautiful photograph, visitors appear to be picking wildflowers. The buildings in the background are probably the Leclaire farm located at what is now the corner of Troy Road and Franklin Avenue. (Courtesy of MCHS.)

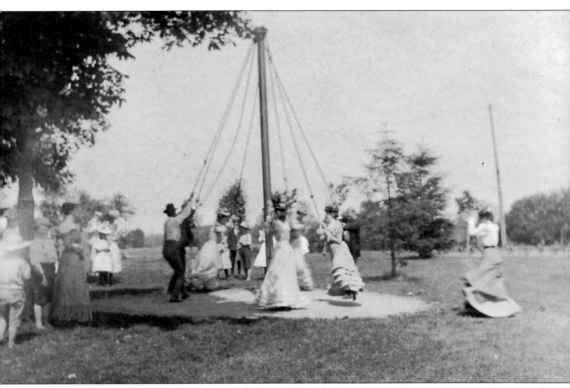

Some of the adults on the Bellamy Club's field trip to Leclaire enjoyed themselves on playground equipment at the Leclaire school house. Members of the club were for the most part young intellectuals who met to discuss the ideas and social theories presented in Edward Bellamy's book, *Looking Backward*. The *Intelligencer* reported that N. O. Nelson gave a presentation as part of the day's activities that included reading from his correspondence with Bellamy. Bellamy was certainly in the circle of men who influenced Nelson's ideas for Leclaire. (Courtesy of MCHS.)

The children on the 1899 excursion enjoyed themselves on the playground equipment at the Leclaire schoolhouse. These children, obviously from well-to-do families, were not the only ones to visit Leclaire. Nelson regularly brought St. Louis orphans and tenement children in groups of 300 or more to Leclaire for a day in the country. One such excursion in 1903 included nearly 1,000 children, transported in 12 railcars. (Both, courtesy of MCHS.)

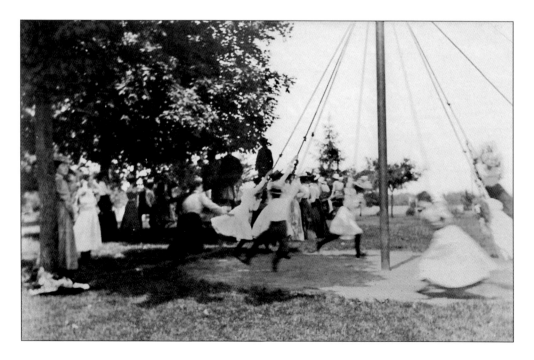

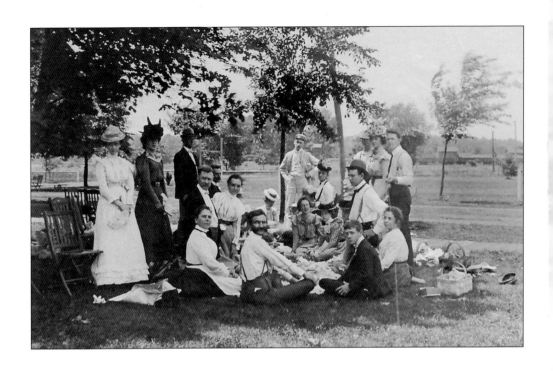

An article in the *Edwardsville Intelligencer* on September 5, 1899 notes, "A merry party of young people from St. Louis came out to Leclaire Saturday morning and spent the day with Mr. and Mrs. N. O. Nelson. They were armed with cameras, lunch baskets, etc., and had a gay time. The factories, stables, and in fact all points of interest at Leclaire, were inspected. All the young people were members of the Clifton Heights Bellamy Club." In the picture above, N. O. Nelson is seated center front. Below is a photograph of visitors waiting for their train home to St. Louis. (Both, courtesy of MCHS.)

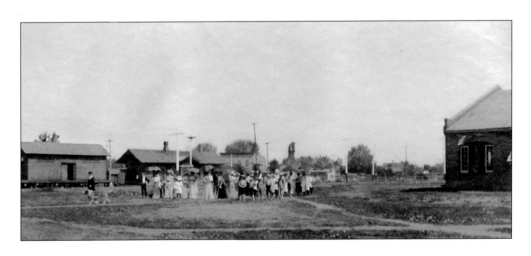

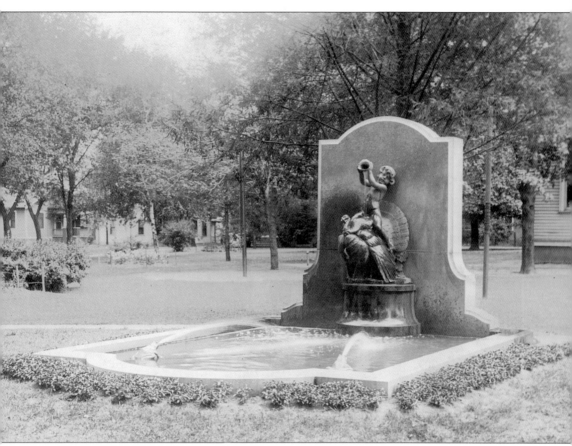

After N. O. Nelson's death in 1922, all the employees at Leclaire agreed to donate a day's wages toward the construction of a memorial in his honor. Other employees from St. Louis and some of the branch offices also contributed. A grateful Nelson family suggested that the memorial be a fountain to reflect "Nelson's philanthropy where he interwove the beautiful or visionary with the practical or useful." The amount collected from the employees was $1,591.20. The balance due on the $7,000 bronze and granite memorial was paid by the company. The memorial's architect was Gabriel Ferrand, and the sculptor was Victor S. Holm, of Washington University. (Courtesy of MCHS.)

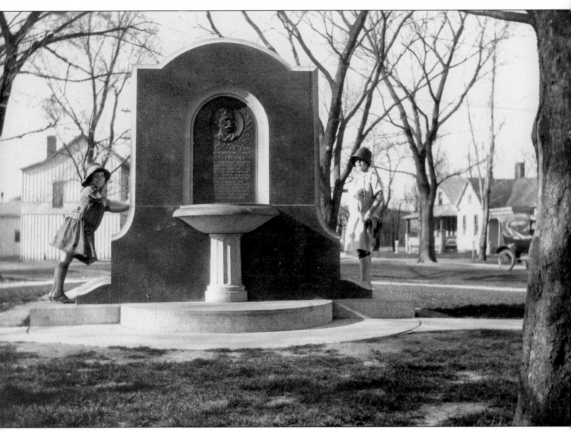

The south side of the memorial fountain is shown here at its original location at the junction of Hale Avenue and Holyoake Road, where it was a favorite backdrop for local photographs like this one from the 1920s. The memorial was moved across town in 1970 to a site next to the new N. O. Nelson Elementary School on West High Street. In 2000, the city of Edwardsville purchased the memorial from the school district and, through the city's Historic Preservation Commission, had it restored to working order and returned to Leclaire. It is now located several yards from its original location, on the School House grounds. (Courtesy of Friends of Leclaire.)

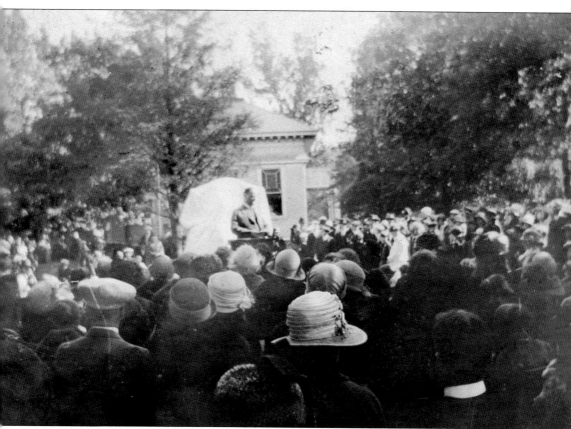

The dedication of the Nelson Memorial on May 24, 1924, drew a crowd estimated at over one thousand. The program included several renditions by the Edwardsville Concert Band, a march by the kindergarten, an introduction by Louis D. Lawnin, and remarks by sculptor Victor Holm. The featured speaker, Dr. E. W. Fiegenbaum, was an orator of some renown and a close personal friend of Nelson; his topic was "My Memories of Mr. Nelson." In this photograph, the fountain is still covered. It was unveiled by James Crawford II, great-grandson of N. O. Nelson. (Courtesy of Missouri History Museum, St. Louis.)

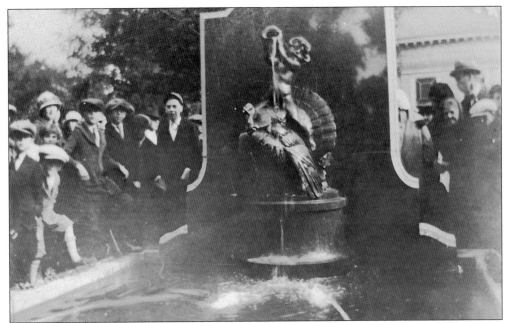

In his remarks at the dedication, Fiegenbaum spoke of Nelson's connection with his workers. He told a story of finding Nelson at the bedside of a typhoid patient at 2:00 a.m. The doctor asked if there were anyone else who could do this work, but Nelson said, "Oh I am only taking my turn with the rest of the boys in taking care of this man who needs us just now." Many personal acts of kindness combined with Nelson's larger projects for social betterment explain why his workers wanted a memorial built in his honor. (Both, courtesy of Missouri History Museum, St. Louis.)

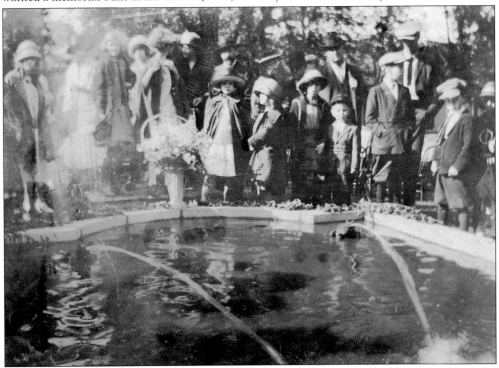

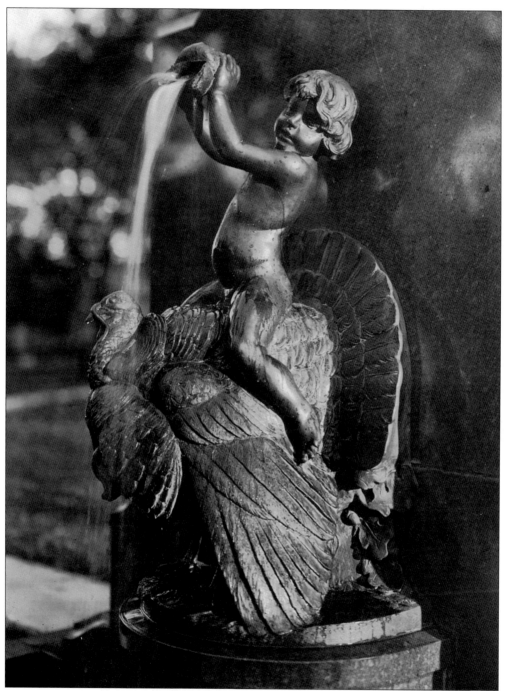

Nelson's love of children and nature was the inspiration behind sculptor Victor S. Holm's whimsical design for the memorial. He wanted to depict both of these interests in a way that would bring delight to children for generations to come. Holm was an instructor at Washington University in St. Louis. His best known work is Spirit of the Republic on the Missouri Monument at the Vicksburg Battlefield in Mississippi. This photograph shows the primary sculpture of the Nelson Memorial as it appeared at the dedication in 1924. (Courtesy of Missouri History Museum, St. Louis.)

www.arcadiapublishing.com

Discover books about the town where you grew up, the cities where your friends and families live, the town where your parents met, or even that retirement spot you've been dreaming about. Our Web site provides history lovers with exclusive deals, advanced notification about new titles, e-mail alerts of author events, and much more.

MADE IN THE USA

Arcadia Publishing, the leading local history publisher in the United States, is committed to making history accessible and meaningful through publishing books that celebrate and preserve the heritage of America's people and places. Consistent with our mission to preserve history on a local level, this book was printed in South Carolina on American-made paper and manufactured entirely in the United States.

This book carries the accredited Forest Stewardship Council (FSC) label and is printed on 100 percent FSC-certified paper. Products carrying the FSC label are independently certified to assure consumers that they come from forests that are managed to meet the social, economic, and ecological needs of present and future generations.

FSC
Mixed Sources
Product group from well-managed
forests and other controlled sources

Cert no. SW-COC-001530
www.fsc.org
© 1996 Forest Stewardship Council

Find Your Place in History.